The Splendour of SOUTH INDIA

Text: S. Muthiah

Photographs: Rupinder Khullar

UBSPD

UBS Publishers' Distributors Ltd.

New Delhi Bombay
Bangalore Madras Calcutta Patna
Kanpur London

Photographs ©
Rupinder Khullar

Text ©
UBS Publishers' Distributors Ltd.

Design
Satish Sud

Design Execution
Supriya Sharma

Edited by
Monisha Mukundan

Typeset in Garamond
by Alphabets, New Delhi

Published by
UBS Publishers' Distributors Ltd.
5, Ansari Road, New Delhi 110 002, India

First published 1992

Printed in Singapore by
Toppan Printing Co. (S) Ltd.

ISBN 81-85273-56-1

CONTENTS

INDIA

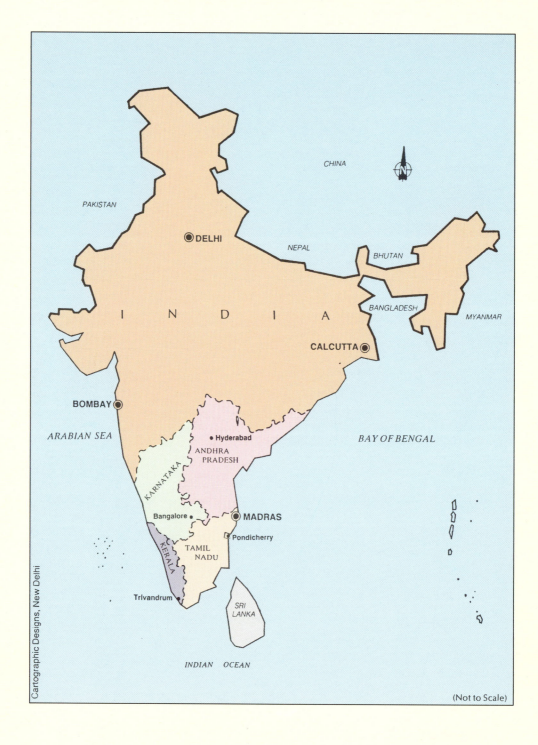

CHINA

PAKISTAN

DELHI

NEPAL

BHUTAN

I N D I A

BANGLADESH

MYANMAR

CALCUTTA

BOMBAY

ARABIAN SEA

Hyderabad

ANDHRA
PRADESH

BAY OF BENGAL

KARNATAKA

Bangalore

MADRAS

Pondicherry

KERALA

TAMIL
NADU

Trivandrum

SRI
LANKA

INDIAN OCEAN

(Not to Scale)

SOUTH INDIA

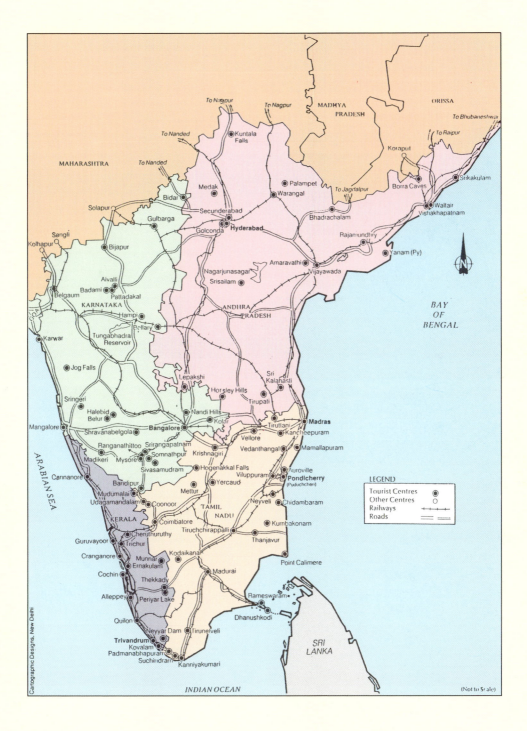

THE SPLENDOUR OF SOUTH INDIA

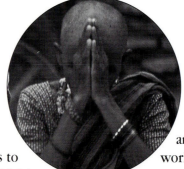

To journey through South India is to journey through variety infinite. From the densely forested slopes of the rugged Western Ghats to the golden beaches of the Konkan, Malabar and Coromandel coasts, from the cool and misty hill stations of the Blue Mountains to the sacred rivers that criss-cross the peninsula, from the towering *gopurams*, minarets and spires of the great religions of the world to the massive forts that are part of several histories, the south of India is all of this and more, an unforgettable journey into a world apart from the rest of India.

South India is Karnataka, Andhra Pradesh, Tamil Nadu, Pondicherry and Kerala, four states and a Union Territory. To most people in the rest of India, everything and everyone in this vast area is Madrasi, to visitors from abroad, it's all South India. Nothing could be further from the truth. Each state is as different from the other as the humid tropical forests of one are different from the arid plains of another and the cool mountain retreats of a third. There are differences in customs and language, history and heritage, geography, architecture and handicrafts.

Yet, for all its differences, there is a unity to South India that's not to be found elsewhere in India. In the conservatism of its people that's quite in contrast to the warm hospitality offered a stranger, in their respect for tradition that's in sharp contrast to their determination to nurture the technology of tomorrow, in their religiousness that seems to contradict their support of political parties born of atheism and a fantasy world of films... In all this and more, they're one people living in worlds so different that a visit to one state is not enough. A journey to India's south must take in all the states – and Pondicherry should not be forgotten in the rush.

Occupying a substantial portion of the plateau of the Deccan, Karnataka was once the home of ancient kingdoms and empires. Now it harbours the boom towns of modern India, their growth assured as much by the equable climate of the plateau as by the friendliness of the people. But there is also another Karnataka, the Karnataka that thrives on both sides of the Western Ghats and which on the western side goes down to the inviting, little-known beaches of the Konkan.

East of Karnataka, lies the state of Andhra Pradesh, the largest of the southern states but the least developed despite its rich potential. Here, Dravidian culture lives side by side with the Islamic traditions that once dominated the princely state of Hyderabad. Here, from a city of palaces, the state was once ruled by the richest man in the world. Elsewhere too in the state are palaces and forts of yesteryear and the relics of the past. It was to this stretch of the Coromandel that the West came in search of the textiles of the East. That tradition still remains as much a part of Andhra's wealth as the rest of its crafts, its verdant jungles and its temples which draw thousands of pilgrims the year round.

Four states and a Union Territory, each as different as it can be from the other. Together, they

provide a unique mosaic that reflects the splendour of South India.

South of Andhra Pradesh is the ancient land of Tamil Nadu. For 3000 years and more there has existed here a continuous tradition of language and culture, art and craft. The result is a temple architecture whose splendid surviving achievements range in age from 1500 years to 500 years. There is no more magnificent temple architecture in all India. But temples, the dances of ages and the exquisite work of master-craftspeople apart, the riches of Tamil Nadu are to be found in its thick western forests, its fertile agricultural belt in the deltas of great rivers, and its unspoilt beaches on the legendary Coromandel and Fisheries Coasts. All this and the heritage of the Age of Empire, for it was here that an empire was established that enabled Britain to paint the maps of the world red for 200 years.

An enclave in Tamil Nadu, smack in the middle of the Coromandel Coast, is Pondicherry. Here, the last faint signs of the French presence in India survive by the side of an ashram that for decades has dreamed of an Utopia. Both, however, have failed to erase a heritage that is staunchly Tamil, even if every Pondicherrian almost as staunchly wishes to remain a part of a territory distinct from Tamil Nadu.

Over the Western Ghats from Tamil Nadu is Kerala, and the Malabar Coast. It was to this fabled coast that travellers came from Arabia, from Rome and China and Portugal. They came in search of spices and timber and elephants and left behind the seeds of Judaism, Christianity and Islam in India.

KARNATAKA

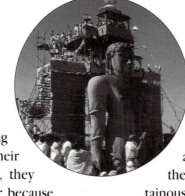

In Karnataka, neither the past nor the present, nor the towers being built for the future suffer from their proximity to each other. Instead, they seem to complement one another because of the attitude of a gentle people who treat rapid change as the natural order of life.

Along the Arabian Sea, the Karnataka coastline is sheltered in the shadow of the Ghats. From Karwar in the northernmost reaches to Mangalore in the very south, it is one stretch of beautiful beach enriched by tall coconut palms. These little-known stretches of golden sand, recently opened up to the holiday-maker, are to be found at Karwar and Malpe, Suratkal and Bhatkal and Ullal. Except during the monsoon, from June to September, these beaches are a safe and beautiful haven for the sunbather and the swimmer.

Feeder roads from National Highway 17 take the traveller into the lush green vegetation of the Ghats. Here, Nature is at its richest in thick rain-forests of teak and sandalwood and bamboo. This is some of the finest elephant country in India and was once famous for its elephant-drives, ending in the *kheddas* (the trapping-operations) near Mysore. The royal *kheddas* have come to an end and the elephant is free to roam the forests with the tiger and the wild ox; the gaur, the deer and the long-tailed langur. And all along this mountainous stretch are some of the best protected wild life sanctuaries in the country, Dandeli in the north, Nagarhole and the Project Tiger's renowned Bandipur in the south.

As popular as its game sanctuaries are Karnataka's waterfalls, the best of them on this stretch of forest-clad mountainous terrain. Gokak in the north and Koppa and Hebbe in the south are pretty, but for sheer spectacle there are few waterfalls more magnificent than the Jog Falls, especially on the Sunday after every second Saturday when the waters of the Sharavathi River are released from the nearby hydroelectric works and descend in four cascades.

In contrast to the unrestrained beauty of waterfalls in spate is the serenity of the coffee plantations of Karnataka, which produce most of India's coffee crop. From Chickmagalur to Madikeri in the southern reaches of the Ghats it is all coffee country. A visitor is always welcome here, to stroll through the well-tended estates, pluck an orange from a tree in a nearby orchard or have a chat with the planter.

Coastal and mountainous Karnataka are, however, a world apart from the rest of the state. That is the Karnataka of the southern end of the Deccan Plateau. It is on this craggy, rock-strewn tableland, that at first sight seems most unprepossessing, that the history of Karnataka was written and it is here that the relics of that past remain. For the traveller seeking not the bounties of Nature but those of Man, this is the Karnataka to journey through.

Bijapur was the once-splendid capital of a Muslim dynasty, the Adil Shahi, which ruled much

of the area from the coast to the central Deccan between the 15th and 17th centuries. It was only after the Portuguese ousted them from Goa that their power began to wane and, nearly a century later, Aurangzeb brought it to an end. The Adil Shahi empire might now be no more, but the wonders they wrought in Bijapur still remain to testify to their building skills.

Dominating Bijapur, both through size and magnificence, is the Gol Gumbaz, the mausoleum of Sultan Mohammed Adil Shah. Built on a platform 185 metres square, it has the second largest dome in the world, 38 metres in diameter. A whisper inside the dome results in the sound being magnified twelve times on the outside. The whispering gallery in the Gol Gumbaz and the acoustical phenomenon of multiple echoes fascinates more visitors than the architecture of the structure. But as a building of beautiful symmetry and a testament to Islamic architectural skill, the Gol Gumbaz towers over all else in a city which contains over 50 mosques and 20 mausolea of great beauty.

Like gems set in the barren landscape that surrounds Bijapur are the other treasures of this capital of yesteryear. In the Asar Mahar are relics of Prophet Mohammed and several beautiful landscape paintings. The Mohtar Mahal is considered one of the finest examples of Saracenic architecture in India. The Ibrahim Roza is a mausoleum famed for its stone work. A 27 metre archway, through which the last king of Bijapur was brought before all-conquering Aurangzeb, is the most impressive part of the ruined citadel. The watch-tower, Upli Burj and a massive cannon called Malik-e-Maidan are amongst the other features of interest.

South of Bijapur are three little townships that were Chalukya cities between the fourth and the ninth centuries. Aihole was the earliest of them and its 125 temples, many of them dating back to the 5th century, are called the cradle of temple architecture of the southern Dravidian school. The Ladh Khan temple, going back to about AD 450 was the first of these shrines and is surrounded by about seventy others of the same period. Known for their beautiful sculpture are the Durga Temple and the Ravanaphadi Cave. And an achievement in construction is the Meguti Temple, 630 stone blocks carefully pieced together to make a beautiful shrine.

Pattadakal, to the west of Aihole, is where Chalukyan temple architecture reached its zenith between the seventh and ninth centuries. Though known to travellers as early as the first century AD, it was over 600 years later that sculptors from the Pallava capital of Kanchipuram were invited by the Chalukya queens to create the fantasies in stone that still thrill the visitor. Here the northern Nagara and southern Dravida styles are blended in many temples, the Papanatha Temple being the finest example of this synthesis with its beautifully carved ceilings and pillars. The Sanghameswara is the oldest temple here, but the Virupaksha is the largest and most interesting, scenes from the *Ramayana* and *Mahabharata* being depicted on it in sculpture and panels. The Mallikarjuna Temple is another well-known shrine, and the scenes from the life of Krishna sculpted on its pillars are its chief attraction.

Still further west is Badami, base for visits to Aihole and Pattadakal. Its hill-top fort provides a fine view of the surrounding country. Within are granaries, a treasury and watch-towers, all indicative of the care with which the Chalukyans

planned their fort. The nearby Maleghitti Shivalaya shrine is notable for its construction, the blocks of stone used in its building being pieced together without mortar. Three Hindu cave temples and a Jain one provide intriguing variety here, for they are the only cave temples of significance in an area which abounds in ancient temples. These four temples, sculpted out of solid rock, are richly carved.

A few hours drive south on the national highway brings the traveller into the heart of yet another great empire that existed in what is now Karnataka. In the 15th and 16th centuries, the Vijayanagar Empire stretched from the Konkan Coast to the Coromandel and consisted of most of the Deccan. The greatest of its rulers was Krishnadevaraya, whose capital Vijayanagar is now the ghost town of Hampi. Spread over 25 square kilometres is an open-air museum of Dravidian architecture and Hindu monuments. In these ruins may be seen Krishnadevaraya's contribution to South Indian art and architecture. Patron of the arts, Krishnadevaraya is remembered today in these remains of palaces and temples that he built and had adorned with some of the most beautiful sculpture in the south.

Not far from Hampi is one of those contrasts so typical of Karnataka. The wonders of Hampi are counterpointed by the Tungabhadra Dam, one of the largest in Asia. Over 2400 metres long and nearly 50 metres high, the dam harnesses the waters of the Tungabhadra River, whose origins are said to be the sweat that trickled down from the tusk of the boar incarnation of Lord Vishnu as he lifted the world on his tusk to save it from the Great Deluge. Legend, ancient empires, art and modern skills all combine in and around Hampi just as they do in much of Karnataka, making it a fascinating tapestry for a visitor to unravel.

Nowhere is this more fascinating than in the state's capital, Bangalore, which many call India's technology capital of tomorrow and the garden city of yesterday. It was in 1537 that Kempegowda, a local chieftain, received a grant of land from the Vijayanagar king. Atop a low hill in the centre of the land he built a mud fort and from it he sent forth buffaloes in the four directions. Where the buffaloes wearied and stopped, he built four towers that still stand, marking the boundary of his city. Two hundred years later, the legendary Hyder Ali who almost ended British hopes of empire before they began, rebuilt the fort in stone, but little of it remains.

What does remain is the tradition of gardens and parks that Hyder Ali and his son Tipu Sultan nurtured. The Lalbagh Botanical Gardens, a riot of colour in spring and summer and a feast of flowers during the annual flower show, were first laid out on Hyder Ali's orders, with both father and son taking a personal interest in every aspect of the planning and development of its 240 acres.

Though nurtured by the British, whose contribution was the glass-house reminiscent of Chelsea's, Lalbagh appears to have aroused their envy too. And almost in competition, as it were, Cubbon Park was laid out over 300 acres closer to their cantonment in the 1860s. These two parks were followed by several others and, between the 1880s and Indian Independence in 1947, Bangalore developed into a sleepy garden city, as much a sanatorium as a haven for the retired seeking a colonial British lifestyle that was going out of fashion even in Britain.

It was well into the Fifties, when Bangalore became the capital of Karnataka, that the garden

city began to shake itself out of the peace of a Rip Van Winkle. Since then it's been India's fastest growing city. And now, as it reaches metropolitan proportions, it is being called India's new capital of science and technology, India's electronics capital and India's brain-bank. The curious thing about these sobriquets for India's boom town is that much of this had been happening in and around Bangalore long before Independence, unnoticed and unsung.

In Cubbon Park are some of the most splendid buildings of 19th and 20th century Bangalore. Of course, the Vidhana Soudha, the palatial building housing the Legislature and Secretariat, built of stone and Indo-Saracenic in style, dwarfs everything else. But at one edge of Cubbon Park is a building of significance, the Visvesvarayya Industrial and Technological Museum. Not only is it the first of its kind to be developed in India, it is a living memorial to the man who made the princely state of Mysore — with which Bangalore was associated before Independence – a pioneer in industrialisation. It was those first steps in industry in a garden environment that led to Bangalore and its environs welcoming free India's new bastions of science, technology and industry and encouraging them to grow in an environment of spacious gardens and an atmosphere of moderation.

The result of all this is that while Bangalore has more scientific research institutions and high-tech industries than any other place in the country, it also has more restaurants, pubs and night-spots than any other place in the South, rivalling in its extroverted lifestyle places like Bombay and Delhi. Yet for all its modern ways, tradition still reigns in the homes and shrines of Bangalore and in many another activity. Typical of this blend of the old with the new is that among the city's success stories are the silk and sandalwood industries that Visvesvarayya founded. Bangalore and Mysore silks are among the finest soft silks in the country and the heady smell of sandalwood is all-permeating, from soaps to incense-sticks, from curios to room fresheners.

Tipu Sultan's palace and the Maharajah of Mysore's copy of Windsor, mansions of a more spacious age and some of the finest modern architecture in India and the shrines of all faiths and modern temples of knowledge combine to make Bangalore unique. It is a city apart from the rest of Karnataka today as it bustles with a new vigour while waiting to enjoy itself the moment the day's work is done. But even as Bangalore changes, its gardens and parks, lakes and shady drives and the laburnum and acacia, jacaranda and cassia, flame-of-the-forest and bougainvillea remain intact.

Heading west from the urban luxuries of Bangalore, the traveller journeys once again into the past, this time to the remains of the Hoysala empire, a journey back into the 11th, 12th and 13th centuries. Hassan is the base camp for a visit to the older capital, Halebid, and the later capital, Belur. In both remain exquisite monuments and temples that are among the masterpieces of Hindu art. Here the sculptor has surpassed himself.

In Belur is the Chennakesava Temple, one of the great examples of Hindu art. Built and ornamented over a period of 100 years and more, the temple has been described as "surpassing, . . . (in) the freedom of handling and richness of fancy", even the "many buildings in India which are unsurpassed for delicacy of detail by any in the world". And if the engineering skills of the ancients needed any testimonial, there is in the temple a pillar that rests

solely on its centre of gravity! The Chennakesava is only the finest of the temples in Belur; there are scores of others at which the visitor can only marvel.

The stone filigree in the temples of Hoysaleswara and Kendareswara in Halebid, ancient Dwarasamudra has to be seen to be believed. The skill of ancient sculptors in creating detail so fine out of stone is unbelievable – yet there it is before the visitor's eyes, surviving the ages and the elements as well.

The Hoysaleswara was left incomplete as history overtook the Hoysala empire. But if it had been completed, it would have been, in the view of one admirer, the last word in Hindu architecture. "In it, every convolution of every scroll is different. No two canopies are alike and every part exhibits a joyous exuberance of fancy scorning every mechanical restraint. All that is wild in human faith or warm in human feeling is found portrayed on its wall". To the less initiated viewer, the sculptor has achieved no less elsewhere in the shrines of Halebid.

Journeying south-east there is contrast to be found in the simplicity of style at Shravanabelgola, a Jain pilgrim centre. Here, tradition has it, the great emperor Chandragupta Maurya spent his last years in a rock cave on a small hill, after renouncing the world and taking the vows of an ascetic. But the sculptor's achievement here is not a remembrance of Mauryan penitence. Here, on a hilltop, there was erected in AD 983 the tallest known monolithic statue in the world. Carved out of a single rock, it stands 18 metres high. This serene representation of the Jain saint Gomateswara is a triumph of simplicity in art and provides a striking counterpoint to the achievements of the Hoysalas.

Due south of Shravanabelgola is the quiet little university town of Mysore, once the capital of the Wodeyar Maharajahs. The Maharajah's palace, the Jagan Mohan Palace that is today palace, museum and art gallery, and the Rajendra Vilas Palace and Lakshmi Mahal Palace which have been turned into hotels are only the best of Mysore's royal residences. Here every mansion seems a palace, but so low key is the lifestyle that even palaces are taken for granted.

The only time the pomp and splendour of a more regal age now comes to life is during the 10-day festival of Dussehra. Then, every September-October, Mysore becomes a fairy-land of lights and all the fun of the fair is enjoyed on its streets. But the highlight is the tenth day, when the procession to beat all processions wends its way past the palace viewing gallery. Gold-caparisoned elephants, camels, and horses, silver coaches and ornamented palanquins, standard-bearers with silken banners and hundreds of brightly uniformed retainers of the royal family march past as the sun goes down. And in the blaze of lights that makes night into day, the Maharajah, who was once part of it all, now reviews the procession.

But if the Maharajahs enjoyed spectacle and pageantry, they were also true to their faith and worshipped in the simplest of surroundings. Just outside Mysore, on Chamundeswari Hill, is the family temple of the Wodeyars. And watching over it is an enormous Nandi, the bull that was Lord Shiva's steed, a magnificent monolith nearly 5 metres high, and an even bigger figure of Mahishasura, the demon who bequeathed his name to Mysore.

Not far from here is a monument to Visvesvarayya as important as the sandalwood oil and silk

factories he established in Mysore to pioneer industry in the state. This most magnificent monument of all is the Brindavan Gardens by the dam of the Krishnaraja Sagar reservoir. With fountains that dance to tinkling music and illuminated waters cascading through terraced gardens, fragrant shrubberies and beds of flowers in colourful bloom, Brindavan is truly a playground of the gods. Only power-cuts and crowds diminish its original splendour.

Mysore is a fascinating town. Yet there is a great deal more to be seen in its surroundings. In Ranganathittoo the birds take over every tree in and around the lake during the breeding season from June to September. During that time, their plumage, of a brilliant white, makes the trees seem snow-covered. Nearby is Srirangapatnam, Tipu Sultan's citadel where he made his last stand against the British. The fort, Tipu Sultan's summer palace with its splendid wall paintings, the mausolea, the serene gardens, even the dungeons, make a handsome memorial to a fighting prince who challenged Britain's might.

Not far from the memories of distant battles is Somnathpur with another splendid example of Hoysala architecture. Built in the 13th century, the Kesava temple here is on a star-shaped base and is famed for its exquisite sculpture.

Heading north-east from here, the traveller journeys to the centre of the Deccan, to Andhra Pradesh, the largest state in South India, and the fifth largest in India.

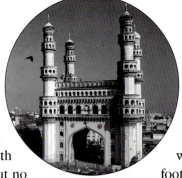

The land of the Telugu-speaking Andhras may just be awakening to the fact that like the rest of the South it has much to fascinate a visitor, but no true Andhra has forgotten the ancient glories of this land where empires grew and fell and merged. The Satavahanas and the Ikshvakus, the Gangas and the Chalukyas and the Kakatiyas, Vijayanagar and the Bahmanis of the Deccan, Golconda and the generals of the Mughals all fought over this wild but fertile land but they also left behind monuments of rare beauty.

In Andhra is India's longest coastline and some of the country's finest beaches. From the verdant coastal plains, the land rises to low, rocky ranges that separate the plains from the forested plateau that is the greater part of the state. Lush green plains lying by the side of barren wastes and sandy swamps, startlingly bare rock formations rising beside ridges covered with thick forest, mighty fast-flowing rivers joined by tributaries to swell their waters create landscapes that offer frequent surprises.

This variety and unexpectedness extends into art and craft, architecture and engineering, religion and culture. It stems from the synthesis of many empires, not the least by the Hindu meeting the Saracenic for the first time on the plateau. The result is almost too much to take at one sitting or in one journey.

Our journey in these pages begins with a drive into the seven hills of Tirumalai atop which is the Lord Venkateswara temple, the richest Hindu temple in all the world. The drive from Tirupati at the foot of Tirumalai provides spectacular scenery around every twisting bend.

Nestling in a bowl among the seven hills, the summits of the hills high above, is Tirumalai town where the temple, befitting its wealth, has built an enormous facility for the accommodation of pilgrims and managed to keep it spotlessly clean. Whether visiting for the day, or staying a few days as much on holiday as on pilgrimage, what is striking is the cleanliness of the township and the orderliness and patience of the thousands who come every day to worship and seek boons from Lord Venkateswara.

As thousands file past the Lord, they praise Him and beseech Him before getting the briefest of glimpses of Him. And then, they pass on to make their offerings. Many have already done so when they had their heads shaved – and two of the most striking sights at Tirupati are the barbers' shed and the conducted tour groups filing into their buses with not a head of hair in sight. Others offer alternatives in cash and gold whose value is often astronomical. Not a soul among the thousands fails to offer something and the temple of Lord Venkateswara, Tirupati as it is usually called, has become a symbol of wealth used wisely and well.

The facilities Tirupati offers the faithful are only a part of its expenditure. Look down the hill as you descend and you will see schools, colleges, hos-

pitals and other welfare facilities sprawling over the landscape, all financed by the Tirupati Trust.

Not far from Tirupati, to its west, are the Horsley Hills, and a hill station that remains almost as it was developed in the 1870s. Close by is the health resort of Madanapalle, Penukonda that was the last stronghold of Vijayanagar with massive fortifications stretching over the hills and Lepakshi with its beautiful temple frescoes and giant Nandi, the sacred mount of Lord Shiva.

Journeying north you pass through the famed mango groves of Banganapalle and then reach one of Andhra's mighty rivers, the Krishna. Following the river east, on either bank a hundred kilometres of thick jungle, is the Srisailam-Nagarjuna Wild Life Sanctuary, a magnificent stretch of rushing rapids and splendid forest teeming with game. The sanctuary starts near the temple town of Srisailam, magnificently sited overlooking a huge gorge. The mighty walls of a hilltop fort protect the exquisitely sculptured Mallikarjuna Temple where the *Ramayana* and *Mahabharata* come to life in stone. The other end of the sanctuary is Nagarjunasagar, a massive man-made reservoir built to store the waters that were allowed in to flood the site of a vast Buddhist establishment of the 3rd century.

At Nagarjunakonda there were once stupas and monasteries, a university and its residential quarters, bathing ghats and an amphitheatre. Here, to ancient Buddhist Vijayapuri, monks came to study from Lanka and Kashmir, Gandhara and China. But as the centuries passed and Buddhism waned in India, this great centre of Buddhism in the South was neglected and deserted. Excavations in the 19th and 20th centuries revealed the vast extent of Vijayapuri. But as the needs of the present-day population grew, the excavations had to give way

to 70,000 acres of water. But by then, all that had been excavated had been removed and reconstructed on a hill-top that is now a popular island museum.

On the road from Nagarjunasagar to Vijayawada is Amaravathi, adjoining ancient Dhanyakataka, a capital of the Satavahanas and the chief centre of Mahayana Buddhism in the South. Once there was, at Amaravathi, a stupa larger than the stupa at Sanchi. Today, only the outline of its foundations remains. More significant, however, are the sculptures of Amaravathi, dating from 200 BC to AD 250. Here Buddhist art at its finest provides evidence that the Amaravathi School influenced the art of all Buddhist countries.

Amaravathi, and the later developments at Nagarjunakonda, were evidence of the important role Buddhism played in the South. But as these ancient cities lost their importance, the jungle took over and Buddhism vanished as an active religion in the South. It was centuries before the ruins were revealed once again.

To the east of these once-Buddhist citadels of Andhra Pradesh is Vijayawada, one of Andhra's few large towns. Ringed by hills, this town on the banks of the Krishna has several hill-top temples of ancient lineage whose legends are as fascinating as their sculpture. But the most striking feature of this market town is a modern wonder, a mighty bridge across the Krishna.

Close to Vijayawada, on the highway north-west to Hyderabad, is a major hill fort which gives its name to the town in its shadow, Kondapalle. The miles of walls have crumbled, but the citadel is still an awesome sight. Quite in contrast to this evocation of martial history, Kondapalle is today renowned as a handicrafts centre that specialises in

the making of brightly-coloured wooden toys. Gods and royalty, soldiers and commoners, animals and birds, plants and fruits and magic boxes all come alive in the hands of these master craftsmen.

Journeying on to Hyderabad, capital of Andhra Pradesh, and its twin city of Secunderabad, a cantonment town where the relics of Empire survive alongside the armed forces it created, is to travel to another world altogether. This is where Hindu and Mughal and British met, but what dominates the city even now is the Mughal style, adapted by the Nizams and softened by the Jungs, the nobles of Persian descent who served them as nobles and ministers.

Perched on the Deccan plateau near the western border of the state, Hyderabad is a sprawling city of hillocks and dusty plains, lakes and rivers, in and around which have developed, over the last four hundred years, a mosaic of mosques and palaces, forts and mansions, gardens and bazaars. Here the Hindu combines with the Saracenic, the Mughal with the British in a medley of architectural styles that seem appropriate in a city where traditional bazaars come alive by the side of modern high-rise in whose corridors you might bump into a gypsy swathed in a colourful costume and weighed down by heavy silver jewellery.

To the west of Hyderabad is the legendary Golconda Fort from where the Qutb Shahi dynasty ruled. The fifth ruler of this line founded a new capital in 1591, on the banks of the river Musi, which he named Bhagnagar after his lady-love, Bhagmati. This was the city whose name was later changed to Hyderabad. Almost a hundred years later, Golconda was conquered by the Mughals and became part of their empire. In 1724, the Nizam-ul-Mulk, the Viceroy of the Deccan, proclaimed his independence and founded the Asaf Jahi dynasty whose head was the Nizam of Hyderabad. In the years before Independence, the Nizam was considered the world's richest man. Evidence of that wealth is to be seen in the palaces scattered about Hyderabad.

Dominating the Hyderabad scene, however, is neither palace nor mosque but a tower with four minarets built as a memorial to a plague that almost wiped out an entire populace. The 16th century Charminar, 55 metres tall and forming a square 30 metres on each side, dominates the Hyderabad landscape and sets the tone for the Indo-Saracenic construction to be found elsewhere.

Near this 'Arc de Triomphe of the East' are the fabulous bazaars that make Hyderabad a shopper's paradise. The search for pearls is one that never ceases, for Hyderabad is a major wholesale market. Here, too, is the glass bangle market and the crystal glass market and the markets for attar, handicrafts, toys, saris and textiles.

Almost as memorable a medley is the city's Salar Jung Museum. Here is bric-à-brac on which no value can be put but which was gathered by a man who sought all things beautiful or of historic value. From jade figurines to cut glass and Dresden china, from magnificent jewellery to clocks from all over the world and exquisite statuary, the Museum has a wealth of miscellany that draws crowds every day to its seventy-seven rooms.

The Mecca Masjid, one of the largest mosques in the South, magnificent Osmania University, a re-creation of Mughal splendour, the Public Gardens with its variety of striking buildings in active use, the marble temple on a hill-top dedicated to Lord Venkateswara and palaces and palatial homes everywhere make Hyderabad a city to be explored

at leisure. But that exploration must leave the traveller time to explore Secunderabad and Golconda too.

In Secunderabad, the Raj lingers as much in military manners and buildings as in frequent parades, in the racing and the polo matches. A little further away is the palace used by the President of India when he moves his office to the South for a short while every couple of years or so.

Still another world is Golconda, a few miles to the west of Hyderabad. The legendary capital of the Qutb Shahi kings from 1518, this deserted fortress-city sprawls over a hill-top. For seven kilometres around the crest of the hill run the walls and bastions of Golconda's citadel. Eight gates and seventy bastions guarded what was once an impregnable fort. A remarkable system of acoustics and an ingenious water supply system are examples of the skills of the 16th century engineers who built this fort, one of the most spectacular in all India.

On the lawns beneath the fort are the tombs of the Qutb Shahi kings, mausolea which reflect the Hindu as much as the Saracenic. From Golconda came diamonds whose names are still an intrinsic part of the romance of the world's most precious stone. The mines are now deserted but walk through the fort or linger beside the tombs of Golconda and the romance of another, more splendid and opulent age seems to come to life.

Near Golconda are Osman Sagar and Himayat Sagar, large man-made lakes created by damming the Musi, Hyderabad's very own river. Beautiful gardens and a modicum of facilities invite the week-ender and the picnicker to the cool of these sylvan surroundings as an escape from the heat and dust of a Hyderabad summer.

To the north of Hyderabad is a virtually 'un-explored' part of Andhra which is really off the beaten track. In Warangal district, lakes and sanctuaries compete for attention with the superbly sculpted temples at Hanamkonda, Ramappa and Bhadrachalam and the fort at Warangal. Here for hundreds of years cotton and carpet weaving have been part of local crafts tradition and remain so to this day.

The Ramappa, Pakhal and Lakhnavaram Lakes in this region are all man-made but each one has been set in such natural forested surroundings that they seem works of nature. The waters are as rich in fish as the surrounding hills are in game. Further east is the Bison Range through which the river Godavari enters the plains. The thickly wooded hills on either side of the river once reminded a traveller of stretches of the Rhine. North of this area nature is even more benign.

The gateway to the coast from this forest paradise is Rajamundhry, a temple town and market centre. From Rajamundhry one travels to the port of Vishakhapatnam, an important naval base and the neighbouring holiday town of Waltair. There are long stretches of beach here that have still not been discovered by the crowds.

Northern Andhra, with its lakes and forests, beaches and tribes is a different experience altogether from the more developed south of the state. That is what makes Andhra perhaps the most fascinating of the southern states. And yet, in many ways, it is typical of the rich tapestry of the South.

TAMIL NADU

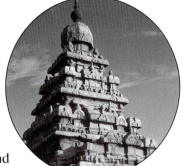

Arriving in Tamil Nadu, the traveller enters a land of infinite natural variety embellished by art and skill through the ages. From the multi-hued sands of Land's End at Kanniyakumari to the golden sands of the Coromandel, from the rain forests of the western hills to the orchards, palm groves and lush green fields of the Kaveri Delta, from the parched plains and scrub forests of the deep south to the cool, green, mist-covered peaks of the Blue Mountains, Tamil Nadu is a land blessed by Nature.

In this land of temples, art and architecture have combined to create spectacular structures. But no less magnificent in artistic concept and construction are the minarets of Islam and the steeples of Christianity. Nowhere in India are the signs of religion and the symbols of worship more apparent than in Tamil Nadu, yet, it elects, in poll after poll, a leadership whose roots are in political movements founded in atheism and whose need for high visibility is demonstrated by smothering every village and town in red and black.

The craft skills of Tamil Nadu are, however, not confined to building bigger and better shrines for posterity. Here there is a centuries-old legacy of inherited skills in textiles, metal, wood and stone. The great traditions of sculpting living rock and burnished metal still thrive; the infinite skills of master weavers produce the finest silks in the world. Palm and reed, wood and metal, fibre and cloth provide material for a wealth of other handi-

crafts that bear testament to a long tradition of craftsmanship.

To explore Nature's riches, to find the bounty of artisans whose skills are rooted in ancient memory would require a lifetime. This journey can only race through that legacy, hitting the high notes and leaving to the imagination the unsaid and the unrevealed.

It is journey that begins at Land's End, the southern most tip of India, beyond which is only the rock on which Swami Vivekananda meditated before journeying west with the message of Hinduism. And then there is the Indian Ocean, stretching to Antarctica. Here, at Kanniyakumari where the virgin goddess is worshipped and Mahatma Gandhi, the Father of the Nation remembered in shrines that are a conglomeration of ancient and modern temple-building skills, three seas meet in an extravaganza of pounding surf and dancing waves. And as they break on the sands of Kanniyakumari, they wash a beach of many colours. Legend has it that when Lord Shiva of Suchindram failed to arrive at the Cape to wed the Virgin Goddess, she cursed the feast that had been prepared, turning the rice and its accompaniments into the multi-coloured sands of Kanniyakumari. It is on these sands and on rocky outcrops nearby that visitors gather to watch Nature at its most splendid, as the sun rises and sets, lighting up the skies in an explosion of colour, and as the moon rises, softly illuminating the blue-black velvet of the sky.

Travelling north from here on a highway and

then east on country roads, journeying through arid country where the palmyrah palm stands straight and tall and provides succor for people forced to eke out a living from unfriendly soil, or travelling north-east along the Fisheries Coast where Francis Xavier once walked and where his memory remains in village churches that compete with each other to build taller steeples, the visitor reaches sacred Rameswaram.

An idyllic island of palms and golden sands, Rameswaram is where every Hindu pilgrim bathes in the waters that wash the island's beaches and prays in the magnificent Sri Ramanathaswami Temple. It was at Rameswaram that Sri Rama, the hero of the epic *Ramayana*, washed away the sin of having killed Ravana, who had abducted his wife Sita. There are over a hundred places on the island associated with the saga of Rama and almost every one of them has a fresh water spring nearby. To bathe in these springs is to add to the merit a pilgrim acquires from bathing in the waters of the sea that gently washes Rameswaram.

There are few better examples of the sculptor's art, than those found in the exquisitely embellished temple at Rameswaram. Over a thousand sculpted pillars stand sentinel on either side of 4000 feet of corridors. To the pilgrim, it is a temple of great sanctity, for worship here is the climax to the rituals performed elsewhere on the island and in distant Varanasi. To the casual visitor it is an awe-inspiring introduction to the art of the Tamil sculptor and temple-builder, whose achievements await the traveller almost every few miles of the way through the rest of Tamil Nadu.

North-west of Rameswaram, the highway leads to Madurai, once proud capital of the ancient Pandya kingdom and today renowned the world over for its fabulous temple and the activity that swirls around it. In Madurai the visitor is in the heart of Tamil Nadu, in the citadel of Tamil culture, its ancient academies of scholarship over 2000 years old. The Madurai of today, however, was built by the Nayaks, the scions of the Vijayanagar empire, around the famed Meenakshi Temple, a splendid example of Dravidian architecture and sculpture.

Nine majestic gopurams, the pyramidal towers atop the entrances of Dravidian temples, can be seen from miles around. The eastern-most of these gopurams is the entrance to the temple and its twin sanctums, one to Lord Shiva and the other to his wife, the goddess Meenakshi. The legendary sacred tank in the temple is where poets and writers of yore tested their literary compositions; if their palm-leaf manuscripts sank when placed on the water, they were worthless, if they floated they were meritorious.

Surrounding the sanctums are several halls, each a fantasy in stone. The most spectacular of them all is the Court of a Thousand Pillars, which, even though it is fifteen pillars short of its name, is a veritable museum of fine sculpture. Not far from these pillars are pillars of another sort, emitting a musical note when struck. And just outside the temple is the hall where the Nayaks, who ruled Madurai, are immortalised in life-size stone.

Close by is the Thirumala Nayak Palace, an exquisite example of the Saracenic influence on Hindu architecture. Its handsome pillars with sculpted capitals and its curved dome, without any visible means of support, evoke constant wonder.

Around the temple the bustle of life never seems to stop, a noisy and colourful contrast to the calm within. In these streets the shopper will find a cornucopia to rummage through, but the best buys are

without doubt the handwoven silks, which are at their best at Festival time, every April/May.

Madurai is known as the City of Festivals. But there is no festival to compare with the Chithrai Festival in April/May when the wedding of the goddess Meenakshi and Lord Shiva is celebrated. For three days the city is packed with pilgrims who throng its streets to catch a glimpse of the deities and make the occasion one of exuberant gaiety.

Another time to be in Madurai is in mid-January when all Tamil Nadu celebrates the harvest festival of Pongal. Madurai is the centre of rich farm country and in the surrounding villages the Pongal celebrations are truer to their ancient lineage than in other parts of Tamil Nadu. Here, when homes are swept clean and bonfires made of last year's unwanted household goods, the flames seem to burn brighter. Here, when the pot of consecrated rice and jaggery boils over, the cries of thanksgiving are louder and more fervent. And here, when the cattle are washed and readied for their benediction, there's more enthusiasm put into decorating them than elsewhere in the state.

The rituals of each of these three days leads up to celebrations every night and especially on the fourth day. During the nights, folk dancers twirl and stamp their feet on the hard ground to age-old rhythmic beats as they balance pots or decorated bamboo arches on their heads and shoulders, don the garb of horses and battle with each other or strike their partner's sticks as they twirl past. During the day, there are the cattle rodeos, most of them on village roads, the most exciting of the contests being the *jallikattu* when daring young men fly through the air in their efforts to capture garlands of clothes and banknotes from the horns of angry racing bulls.

Heading north from this traditional heartland of rustic simplicity, where the real deep south of Tamil Nadu ends, the traveller may either go to the junction town of Dindigul, turn west and head for the cool of the hills or go east into the fertile Kaveri Delta where every village has a temple more magnificent than the previous one. The beaten track is the journey through the land of those great empire-builders, the Cholas, who celebrated military triumph with architectural magnificence. Less visited, except during the summer when the holiday hordes pour in, are the hill stations the erstwhile British empire-builders created in the Palni Hills, the Anamallais and the Nilgiris.

In the cool of the hills are Kodaikanal and Ootacamund, Coonoor and Kotagiri, and such game sanctuaries as Top Slip and Mudumalai where the elk and the wild ox roam. Placid lakes and beautiful gardens, quiet forests and downs, rushing rivulets and thundering waterfalls enliven these hill stations. During the summer, flowers light up the slopes and the gentle weather beckons the visitor outdoors. But when the temperatures are lower and mist washes the visitor's face, these hill stations are for the adventure-lover and the sportsman and those who like to curl up with a book by the fire. Little bits of once-upon-a-time England they remain much of the year, though they no longer ride to the hounds in these parts, even if there is a Master of the Hunt. Much of daily life in these parts centres on the legacy of the British; the tea and coffee estates that blanket the slopes and create a lifestyle all their own.

In contrast to the hills are the lush fields of the land of the Cholas. The paddy fields and plantain farms, mango orchards and coconut groves begin at Tiruchirappalli – that can only be called Trichy.

Citadel of the Cholas and the Pallavas and the Nayaks, it is a city that comes into focus as one end of a vast battlefield on which were fought the Carnatic Wars, in which victory over the French left the British with the beginnings of empire. Almost a monument to those historic events is Trichy's Rock Fort towering over a vast, level plain.

The fort, in which a temple has been built at various levels, overlooks yet another of Tamil Nadu's famed temples. Between the Kaveri River, which flows by Trichy, and its tributary the Coleroon is the island of Srirangam and on it stands the temple dedicated to Sri Ranganathar. One of the biggest temples in India, it is enclosed within seven concentric walled squares, the outermost almost a thousand yards square. This huge temple complex is to the followers of Lord Shiva what the equally magnificent temple in Chidambaram, further east, is to the flock of Lord Vishnu.

Befitting a temple with magnificently sculpted gopurams, thousand-pillared halls and untold wealth in splendidly crafted jewellery, the Srirangam Temple now has the tallest temple tower in India. This was an unfinished gopuram that stood forlorn by the side of three magnificent towers. But when the temple authorities decided some years ago to finish what was unfinished, they discovered an unbounded enthusiasm. Completed in the mid-1980s, the soaring eleven-storey tower is truly a masterpiece.

A few miles below the temple is the Grand Anicut built by the Cholas in the eleventh century to keep the Coleroon and the Kaveri separate and divert the Kaveri waters to the fields around their capital of Thanjavur. 610 metres long, 18 metres wide, the dam, a monument to Chola engineering skills, is every bit as magnificent as the temples

they built in and around Thanjavur. The Tamils have been called "the greatest temple-builders in the world" and the Great Temple in Thanjavur is an exhibition of the incomparable skills of those builders.

Built in the tenth and eleventh centuries, when the Chola Empire, under Raja Raja Chola, was at its apogee, the Great Temple set a new style in temple-building. For the first time, the gopuram over the sanctum towered over the portal. This magnificent tower, 66 metres tall, has at its peak a dome that rests on a single block of granite weighing, it is estimated, 80 tons. This block was moved into position along an incline that began four miles away! To match this magnificence is a massive sacred bull in the courtyard chiselled out of a single rock. Elsewhere in the temple are some splendid examples of Dravidian sculpture and several frescoes every bit as striking as those of Ajanta.

What Raja Raja Chola began, his son Rajendra Chola continued with equally superb temples in Gangaikondacholapuram, Dharasuram and Tribhuvanam, each with a main tower soaring over the sanctum. But in not one was son prepared to build bigger than his father, even though in sculptural excellence these are superior. Sculptural splendour in the Kaveri Delta is at its peak in the famed temple of Chidambaram, dedicated to Lord Nataraja, the manifestation of Lord Shiva as the Cosmic Dancer. Here the thousand pillared hall once echoed to the celebrations of Pandya and Chola triumphs. Here, in two of its four splendid gopurams, are perfect depictions of the 108 postures of the *Natya Sastra*, that treatise on the science of dancing which laid the foundation for the classical dance form, Bharata Natyam, whose

exponents still learn the art from the *gurus* in Thanjavur villages.

Between Thanjavur and Chidambaram is Kumbakonam, a town of great antiquity that still retains much of its old-world charm. Another major temple town, rich in sculptural and scholastic tradition, Kumbakonam comes alive once every twelve years when the bathing festival at the sacred Mahamakhan tank attracts pilgrims from all over India. The rest of the year it attracts those seeking its antique-style gold and silver jewellery, bellmetal work and brassware, and the leaves of its betel vines. But this is an attraction that every town in the Kaveri Delta offers, added evidence of the skills of the artisans and farmers of the region who could work with equal ease on a scale to suit a temple or one to suit an earring.

Moving north-east from Thanjavur, the traveller crosses from Chola Nadu into the land of the Pallavas, an ancient land best visited from a city which never existed in that age yet is the Gateway to South India today, Madras. One of India's four great metropolises, this capital of Tamil Nadu is a city the British founded in 1639 with a tiny fortified warehouse on a strip of no-man's land. Today, that warehouse is Fort St. George, one of the best preserved British forts in India and where a visitor, with every step, walks with the history of the biggest empire the world has ever known. Vestiges of the empire that began with Fort St. George are few in Madras, but those that exist are to be found in fort and tombstones, in church and in fine examples of Indo-Saracenic architecture.

But much older than Madras is Mylapore, the ancient Pallava port that is centuries older and was known to the world as a major entrepot and home for a while of the Apostle who Doubted, Thomas

Dydimus. Here, faith in his legend is as much part of everyday life as the Pallava sculptural heritage found in the temples of Kapaliswarar and Parthasarathy and the Saracenic splendour found in the Big Mosque and the palaces of the Nawabs of Arcot. Following the trail of Thomas in Madras, looking at the places where Clive the Senior as well as the Junior began their careers, enjoying the revelry on the sands of one of the biggest beaches in the world or taking in the cinematic influence that makes everything from hoardings to gestures bigger than life, are all part of the wide variety Madras offers to the visitor.

From Madras, Pallava glory is easily visited, the city's Golden Triangle offering the visitor a peep into a world of thirteen and fourteen centuries ago. South of Madras is Mamallapuram, the major port of the Pallavas. Here they left behind, almost in midstroke of the chisel, it would seem, an open-air museum sculpted in living rock. Monolithic temples, temples scooped out of rock and embellished with sculpture and, above all, the world's largest bas relief, *Arjuna's Penance*.

If Mamallapuram was embellished to demonstrate the sculptor's rare skills, Kancheepuram, the Pallava capital became a town of a thousand temples as a consequence of its illustrious heritage. Long before the temples it was considered one of the seven sacred cities of the Hindus. The temples were only Pallava tribute to the ancient city's religious lineage. Over a hundred of Kancheepuram's thousand temples still survive, and in several of them the Pallavas have left their imprint in sculpture.

Like Madurai, Kancheepuram is a town of festivals and a centre of ancient handicrafts, renowned as much for its religious heritage as its handloom

silks. Kancheepuram silks are the finest in India and seeing them woven on the roadsides or displayed in the scores of shops in the town is a dazzling sight. But a Kancheepuram saree does not merely dazzle; its very name is a guarantee of particular excellence, weight and colour-fast design. That is what makes the Kancheepuram saree so visible at Madras weddings, at music and dance perfor-mances during the city's famous 'Music Season' every December and on the Bharata Natyam stage. That stage is best seen on the road from Madras to Mamallapuram at Kalakshetra, where Bharata Natyam dancers learn the ancient art in traditional surroundings transplanted into an urban milieu from the villages of Thanjavur.

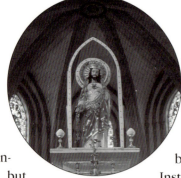

France's last outpost in India is less than a four hour drive from Madras. The driving distance may make Pondicherry seem an all-day excursion, but here is a splendid living memorial to another age that cries out for greater attention. The last vestiges of France's Indian empire may be the statues of Dupleix and the Maid of Orleans, the *kepis* of the policemen and the *Rues* on the road nameboards, much of the city might be just another part of Tamil Nadu, but enter Ville Blanc, the area by the beach, and you will be transported to another world.

Pondicherry's beach is one of the most magnificent on the Coromandel Coast and, unlike the others, it is used by many the way a holiday-maker's beach should be. But more than the beach is the image François Martin and his successors built here of a typical French settlement by the sea. Gleaming white houses, grandiose official buildings, towering Gothic churches and a promenade lined by monuments, all by a beach where the sands sparkle and the sea seems to turn a special turquoise just for the visitor.

In the Cercles, or Clubs, where those who still serve France or who once served her faithfully gather, there's the chatter of French or Tamil and English made musical by French accents. Cordon Bleu cuisine or Vietnamese Orientale suddenly crop up in the most unlikely of places, while a reminder or two of past culinary glory still remains in the few remaining hostelries of another age. But

it is in Raj Bhavan, where Dupleix once lived, and in the Maire by the beach, in the Museum and the French Institute, where cartography is pursued as diligently as French culture, that France comes alive in India.

But if France and the French are memories battling to maintain a presence, religion and faith flourish with almost no effort at all in this little Union Territory that holds on tightly to its special relationship with the Central Government of India. In the cavernous Church of the Sacred Heart of Jesus with its beautiful stained glass windows, in the several churches which take their Gothic cue from the Sacred Heart Church, and in the several temples in the town, in Villianur, and in its enclaves, like Bahour, worship is a way of life. Nowhere is faith more enthusiastically displayed in public than at the annual church or temple festivals or at Masi Magam in February/March when the deities are taken from thirty-eight temples for immersion in the waters of the Bay of Bengal and the faithful follow them into the sea. There are also numerous fire-walking festivals in the territory in which men, women and children stroll across burning embers with belief in divine protection their only safeguard against blistered feet.

In startling contrast is the serenity and spartan simplicity of the Ashram that Sri Aurobindo founded and the Mother nurtured. Here they come from all corners of the world to pay their respects to the founders at their tombs and then stay on to

meditate over what Sri Aurobindo and the Mother taught. But solace is found not only in meditation and yoga; there's art and culture, agriculture and cottage industry and handicraft. Together they make a unique way of life where East and West blend in mysticism and self-satisfying toil that produces objects of great beauty. They have also created Auroville, the City of Dawn, a modern Utopia, just north of Pondicherry. That it has not succeeded to the extent the Mother had hoped only demonstrates the frailty of human beings.

A city with a hallowed past where remnants of Roman settlements 2000 years old have been found, Pondicherry remains a curious memorial to the dawn of empire. It was here that Dupleix and Jeanne Begum dreamed of what they could make possible and it was around here that, in the battles of the Carnatic, the British not only punctured French dreams but took over from where the French left off. It was here too that the French provided sanctuary to Sri Aurobindo and Bharathi and Bharathidasan and others with dreams of freedom from the British. Here, dreamers created poetry and literature as well as a haven of faith amidst high stone walls that soldiers had bloodied for years. There's something still splendidly free about Pondicherry, making it one of the most relaxed, laid-back destinations in South India.

Shadowed by mountains clad in luxuriant vegetation on one side, bathed by gentle blue seas lapping golden beaches on the other, the paddy fields fed by scores of streams and backwaters, Kerala seem almost paradisal. Perhaps that picture of Eden was the reason that the great religions of the world first sought Indian shores here.

It was to Kerala that the Jews of Asia came in the first years of the Christian era, and even before, as much in search of sanctuary as of spices and timber and ivory. It was to Kerala that Thomas who Doubted came to preach the Gospel and here it was that he and those who followed him from the western reaches of India settled. And it was to Kerala that the followers of the Prophet came to build the first mosque in Asia. It is no wonder that when Vasco da Gama opened up the first trade routes to India by sea, it was to Kerala he came, to be followed by traders from other European seafaring nations.

The road from the east, across the Ghats, brings the traveller to Calicut, where Vasco da Gama made his first landfall. But the leaders of those religions who made Kerala the most cosmopolitan part of India all arrived further south, at the ancient entrepot of Musiris, now known as Cranganore or Kodungallur. Little remains in either place to commemorate the roles they've played in India's history, but in between are Trichur and Guruvayoor where the symbols of Hinduism remain most

visible. The multitude of faiths that thrive in Kerala, their adherents at one with each other, is the true richness of Kerala.

Guruvayoor is where the Hindus of Kerala flock to worship at the temple to Lord Krishna. Here vows are made as devotees weigh themselves against grain or jaggery or vegetables and offer these measures to the Lord. During the ten days of the annual festival in February/March, the temple's large stable of elephants participates in races and daily processions at which they are caparisoned in all their glory. A later festival, in November/December, brings the most famous musicians of Kerala and others devoted to Lord Guruvayoorappa to play for the Lord in a musical extravaganza that is one of the South's major music festivals.

Further south is Trichur, the 'Town with the Name of Lord Shiva' and to him, on the mound around which the town is built, is dedicated the city's famed Vadakkunnathan Temple, one of the finest examples of Kerala temple architecture. Here, in the main temple and its supporting shrines, is a wealth of the woodwork for which Kerala is famous.

The biggest temple festival in Kerala is celebrated here every April. The Pooram festival is sheer spectacle with richly caparisoned elephants in their scores participating in the daily processions. At night, the skies are lit with what many believe is the finest fireworks display in India, if not Asia.

Besides temple and Pooram, Trichur is known as

a centre of scholarship. Three state Academies, that of literature, song and dance, and painting and sculpture, are headquartered here. So is the University of Calicut's School of Drama. Together they make Trichur perhaps the most important centre of the state's ancient cultural tradition. Nearby, Cheruthuruthy, where the ancient dance tradition of Kathakali is nurtured, adds to the lustre of Trichur.

Kathakali ('story-play') is a 400-year-old tradition of dance-drama that 'modernised' still older traditions, even incorporating forms of the martial arts of Kerala. Wearing towering crowns of wood, ornate jewellery and billowing multi-skirts made of yards of cloth, with handsome faces made into painted masks through a rare expertise in make-up, the all-male troupe of dancers present stories from the ancient epics of India to the throb of drums.

Using dance and mime and an intricate language of eye movements and hand gestures, the dancers play out their stories on a primitive stage in the light of tall, gleaming brass oil lamps that fuel the imagination.

Today, Kathakali ranges from the 'tourist' to the modern in which Christian parables and Western classics are narrated. But Kalamandalam in Cheruthuruthy is where they have tried to keep the dance form pristine. There, boys spend a dozen years training to dance like the classicists of yore for eight to ten hours at a day. Hours of rolling eyeballs, contorting faces, flexing facial and neck muscles, pounding the hard floor with their feet and practising an intricate array of gestures day in and day out, year after year, make them the true stars of the Kathakali stage. But to the visitor, the scores of daily performances to be seen in any major city in Kerala will be as exciting; Kalaman-

dalam only demonstrates to the visitor how much more is needed to get beyond the daily show for the uninitiated.

South of Trichur is ancient Cranganore, where the inland waterways of Kerala begin. Local people travel by boat on the placid backwaters from one place to another. The 250 kms from Cranganore to Trivandrum (Thiruvananthapuram) can be done by boat, using the palm-shaded backwaters and an intricate network of canals. Today, fast motor-powered launches ply these waters, but it is much more fun to take a slow, thatch-covered country-boat of Chinese origin, which is poled along laden with a cargo of coir or coconut husks.

The heart of boat country is Alleppey, the 'Venice of the East', situated on the Vembanad Lake, the longest lake in India. A maze of canals gives the town its sobriquet, and coir and black pepper its riches. But to the visitor, travelling the backwaters and being part of the crowds on Boat Race Day are the most interesting part of Kerala's backwater country.

The slow boat or a cruise on the faster boats can be enjoyed at any time of the year, but it is only in August/September, at Onam, the harvest festival, that the giant snake-boats come out to challenge each other. The second Saturday in August is Boat Race Day in Alleppey, the biggest and most exotic competition of its kind in the country. The highlight of the day is when the *Chundan Vallams* race against each other. These are giant snake boats, each a hundred feet and more in length, with gaily decorated snake-like prows. Each is crewed by over a hundred men whose oiled muscles gleam in the sunlight and whose voices drown the roar of the crowd as they chant the oars' beat with songs. There's nothing like it anywhere else in India,

perhaps even in the world, except in other boat-race centres in Kerala. Places like Aranmula and Payipad, Kottayam and Cochin are some of these centres, the first two of which have long traditions of boat-racing associated with temple festivals, the latter having instituted the festivities in more recent times.

But before getting to Alleppey, there's Cochin, the 'Queen of the Arabian Sea'. Cosmopolitan Cochin, the commercial capital of Kerala, has been known to the world from the time of the Phoenicians and Arabs, the Romans and the Chinese who traded in the entrepots of Asia. Its placid natural harbour and its friendly people assured every sailor safety and every trader fair trade. Today, it is sheer joy to cruise through that harbour, stopping off at the various islands that are part of Cochin's history.

Seeing coir rope and household furnishings being made from coconut fibre, watching shrimp being prepared for export, visiting ancient temples and churches, forts and palaces, all add enchantment to a cruise in the placid waters of the port of Cochin. But even more dramatic is Fort Cochin, the peninsula where Vasco da Gama and Albuquerque made Portuguese power secure with a fort to protect the sheltered anchorage they found on the Arabian Sea. Fort Cochin and Mattanchery, its 'Indian town' which predates the Western conquerors, are Old Cochin today, a historic landmark of protected architecture dating to the Portuguese, Dutch and early British periods.

It's not, however, these historic buildings of yesteryear that create the unique skyline Old Cochin offers those who view it from the sea. Right around the coast of the peninsula are the famed Chinese fishing nets of Kerala, looking for all the world like giant Horatio Alger creations. Living symbols of Chinese influence on this coast, an influence reflected in Kerala roof styles, its china clay creations, the cargo boats that ply its backwaters, its crackers and the headgear of its fishermen, these giant fishing nets are worked the year-round by teams of fishermen who dip into the waters nets hanging from counter-weighted poles and scoop out the catch as the nets rear back into the skies.

Behind the nets is Fort Cochin, much as it has looked for centuries. Here there is St. Francis's Church, Protestant successor to Roman St Anthony's where Vasco da Gama was buried. The oldest Christian Church built east of Suez by the European trailblazers, it is a church which reflects its antiquity in every one of its prized possessions. Not far from it is Mattancherry, where still more history awaits the visitor.

Here, Portuguese colonial has teamed with Kerala Chinese and Burgher Dutch in a palace which is now an archaeological masterpiece rich in vibrantly coloured murals. Near it is Jew Town, now almost a ghost town, but in its immaculately kept homes and synagogue a living memorial to the tolerance of Malabar which has had Jewish settlements ever since the Roman destruction of the Second Temple in Jerusalem in AD 70.

Jew Town in Cochin, however, is not the legacy of those first settlers, the Seraphaic or Black Jews from West Asia; rather, it has been a creation of the Sephardic or White Jews who fled the Inquisition in Europe. Here they built a synagogue that is perhaps the most beautiful in India, embellished with Chinese tiles and possessing riches of gold and silver. Near the synagogue is the Coonen (Leaning) Cross where Kerala's Christians of Thoman antiquity swore allegiance to the churches of West Asia that ante-dated the Roman Church whose

ways the Portuguese brought with them.

South of Cochin is Kerala's capital, Thiruvanathapuram, small, green and clean. Its Sree Anandhapadmanabhaswamy Temple is a splendid example of the way Kerala wood-working traditions and Chinese influences enriched Dravidian temple architecture. But temples, the city's several palaces that once belonged to Travancore royalty, its parks and art galleries are not all that make Thiruvanathapuram a delight to the visitor. It's the backwater lagoons and the golden beaches that make the city and its environs a special holiday destination.

Typical of these riches are Veli-on-the-backwaters and idyllic Kovalam, a sheltered bay with dazzling white sands. In both holiday resorts, yoga and herbal massages, Kathakali and Kalaripayattu, the ancient martial art pre-dating Kung-Fu, complete the day when the sun goes down.

From Trivandrum and Cochin the highways eastward, into the Ghats and the high ranges that trail from it, lead into some of the most fascinating parts of the state. Climbing through plantations of palm and spice, visitors reach the cool of the hills where tea carpets the slopes in an unending series of estates. Here and there in this tea country, Kerala's hill resorts embellish the carpet. But most inviting of all are the wild life sanctuaries of the finest elephant country in India. At Thekkady, the herds come down to Periyar Lake and at Idukki they trumpet a chorus to man's building achievements in a wilderness where the waters have been trapped to create awesome power.

Heading south from this tropical paradise, within minutes of leaving Kerala, there's Land's End, an ocean stretching from sacred shores to what seems the end of the world, a sight more awesome than the cosy warmth of the lush vegetation and golden sands of Kerala.

KARNATAKA

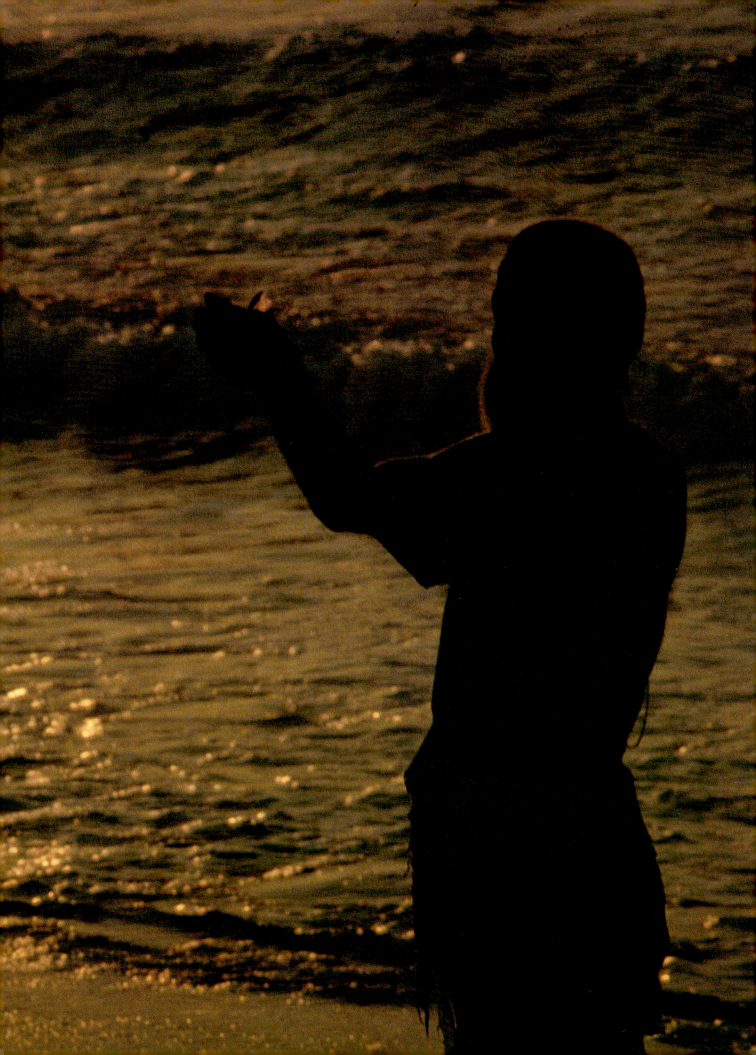

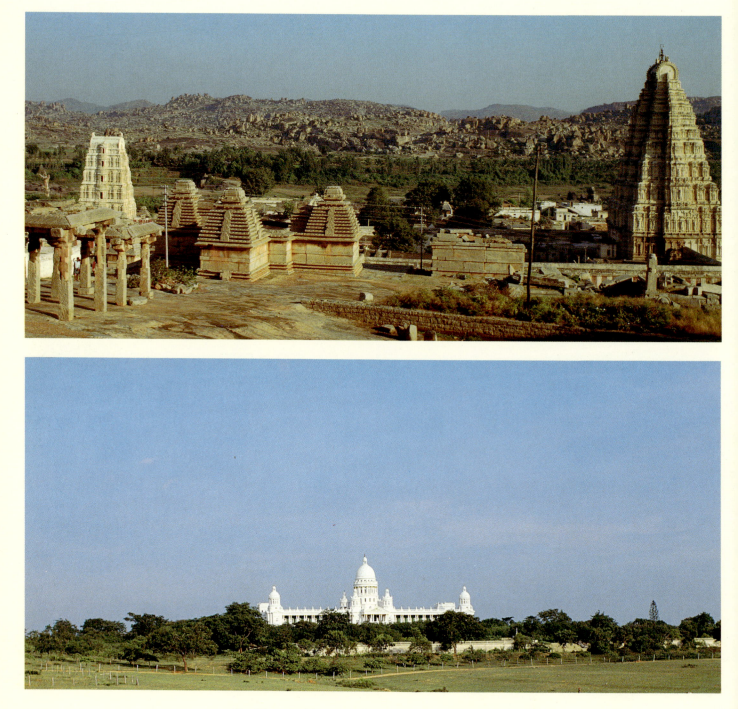

Top: The ruins of the capital of the Vijayanagar empire at Hampi.

Above: Lalitha Mahal, a palace, built in the 1930s, is now a luxury hotel.

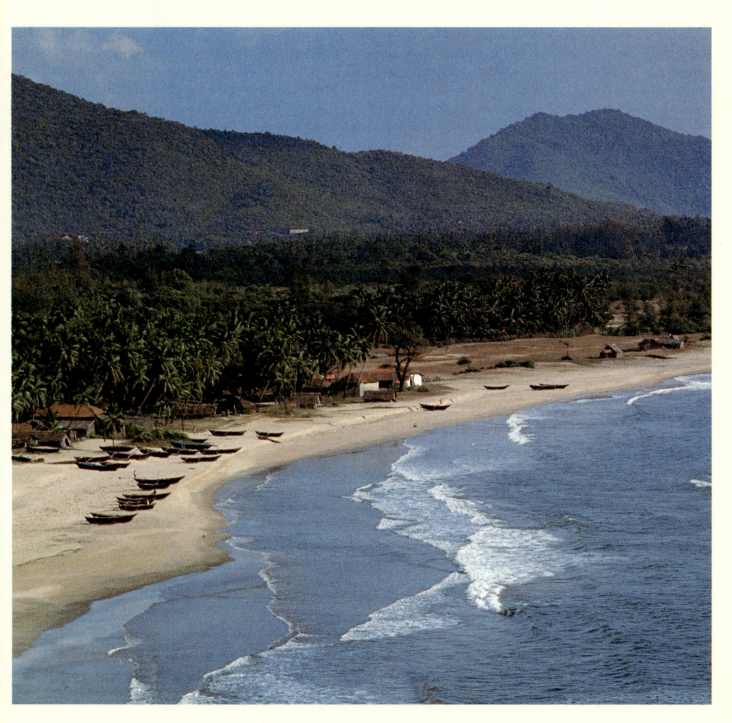

The Karnataka coast has some of India's most beautiful beaches, such as this one at Karwar.

Following page: The Maharaja of Mysore once held court in this opulent darbar hall.

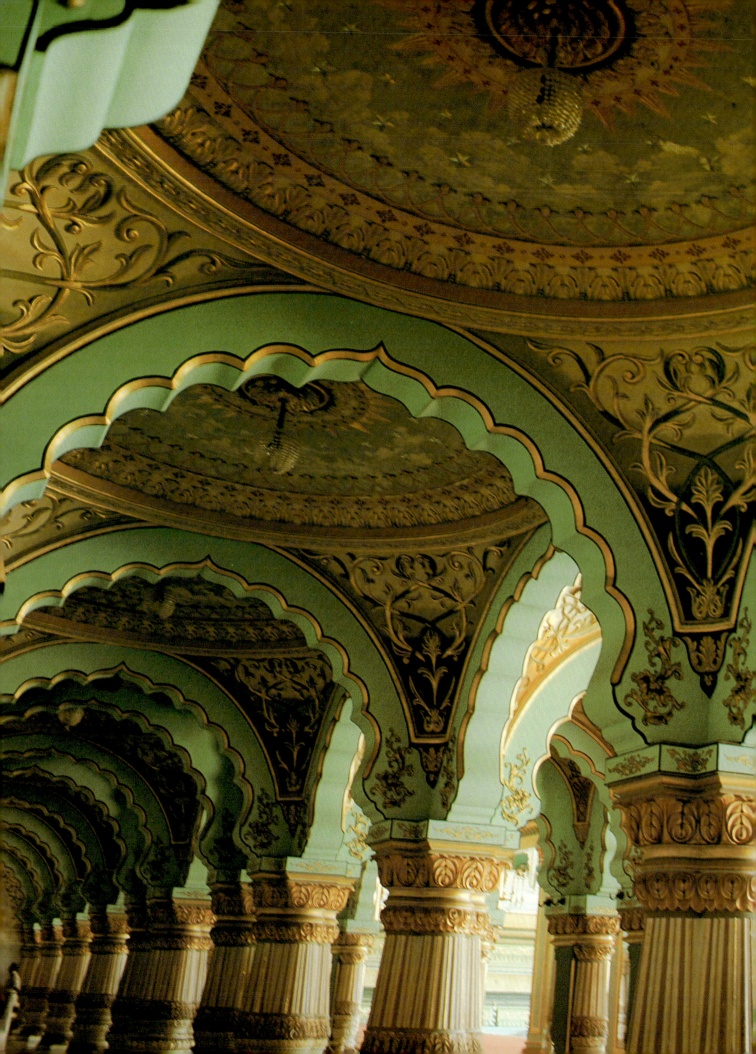

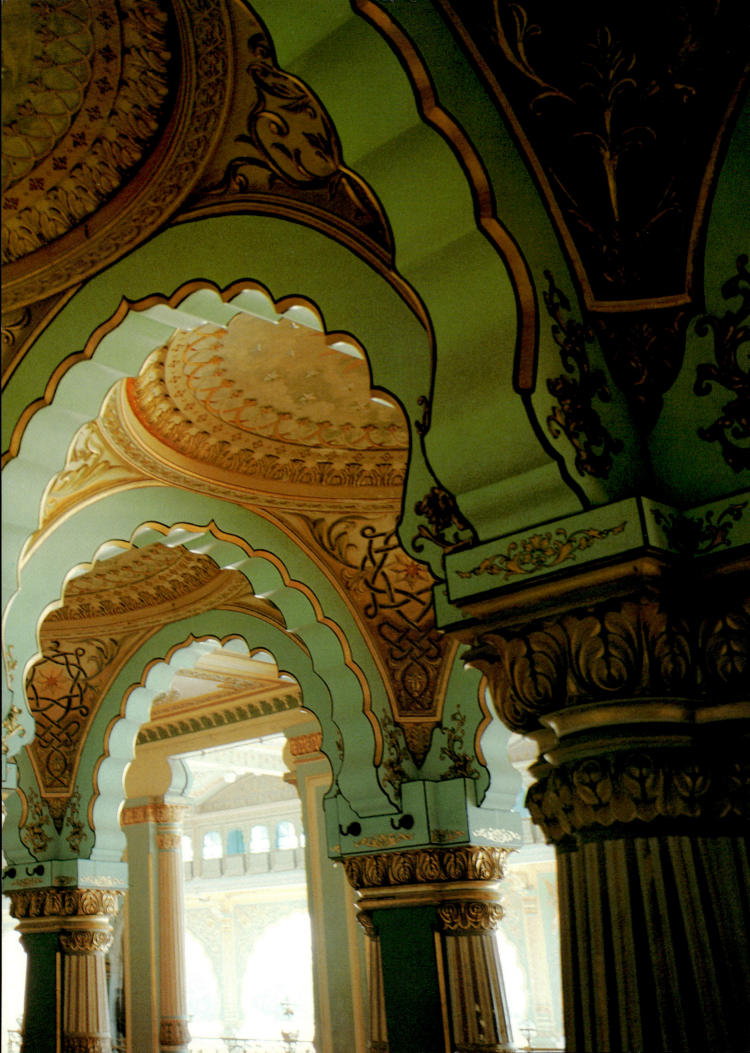

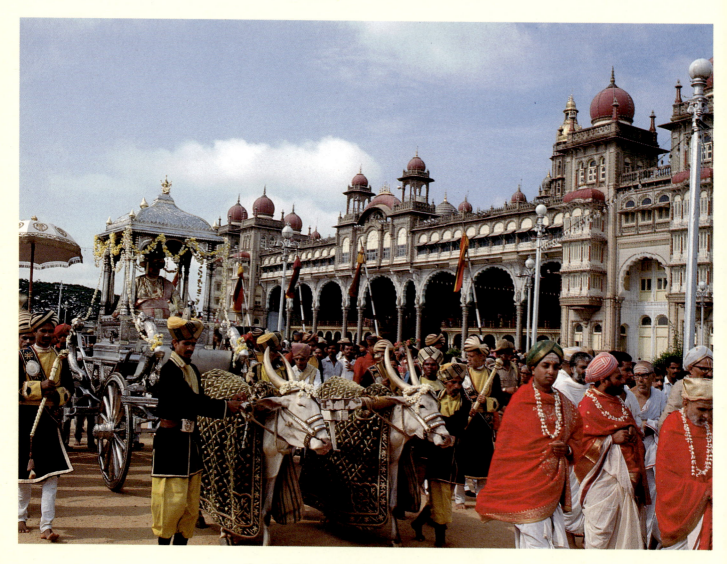

*Above: The Maharaja participates in a splendid procession,
to celebrate the festival of Dassehra.*

Facing page: The Amba Vilas Hall of the palace in Mysore is richly decorated.

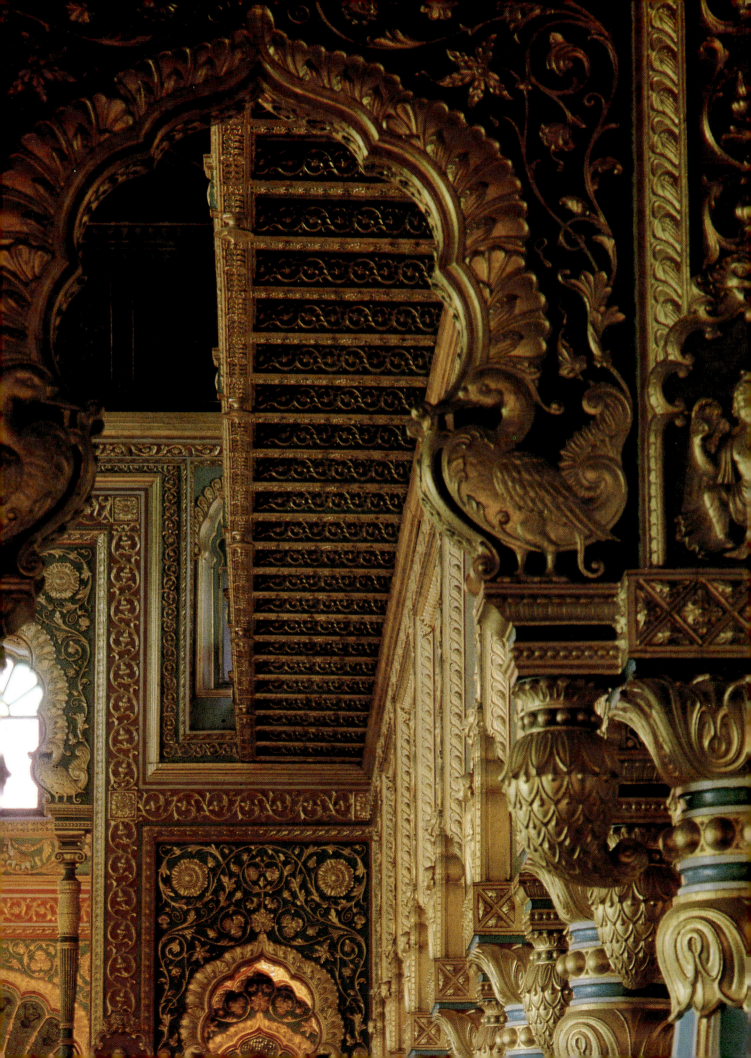

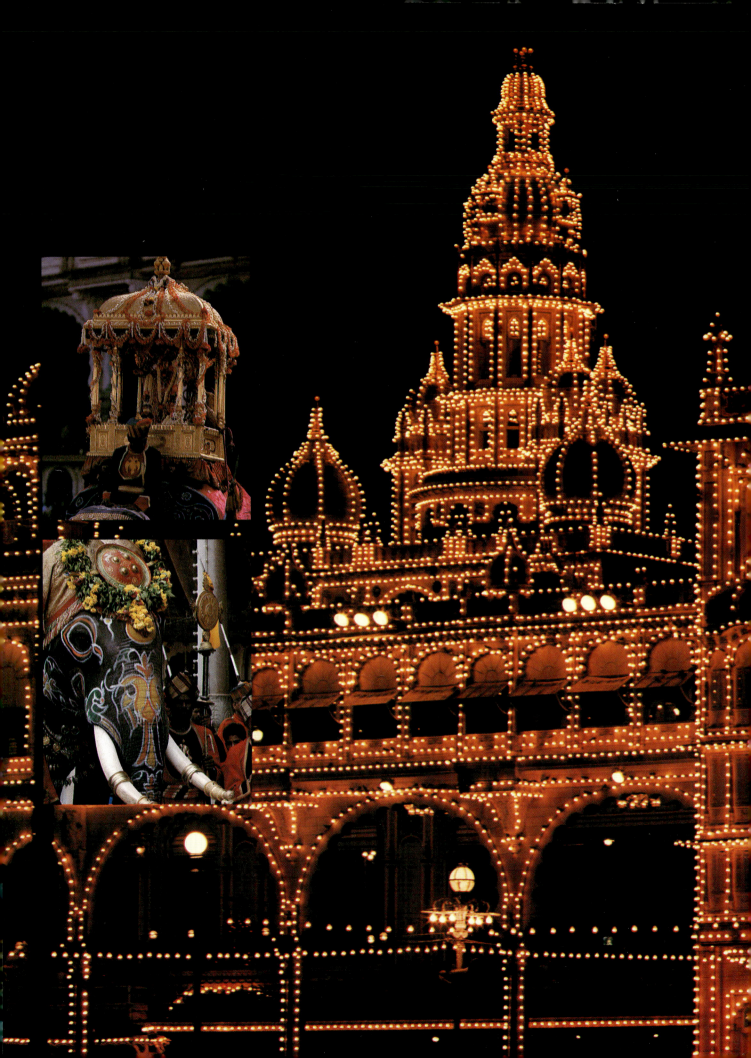

The Mysore Palace is illuminated at Dassehra time
Inset: Caparisoned and painted elephants
at the Dassehra procession in Mysore

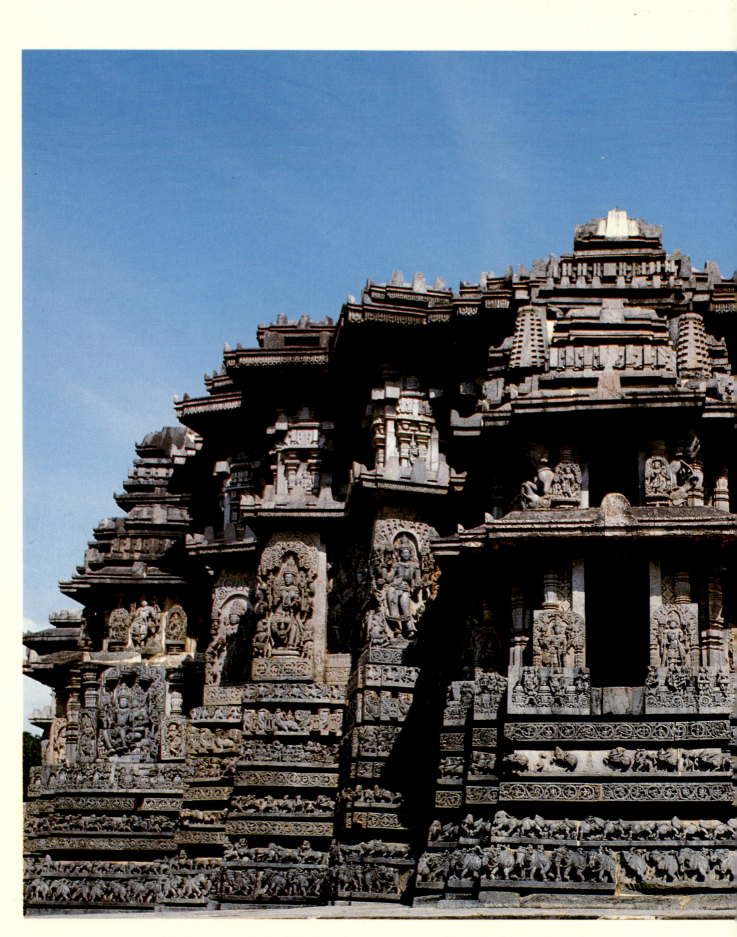

The Chennakesava temple at Belur is star-shaped, and every inch of its surface is intricately carved.

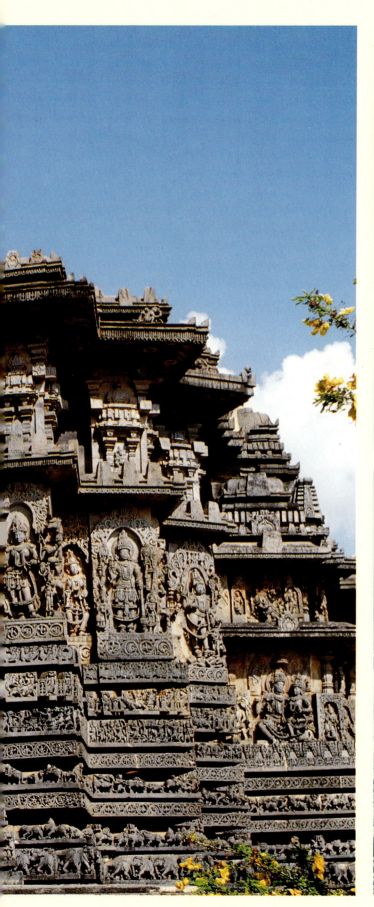

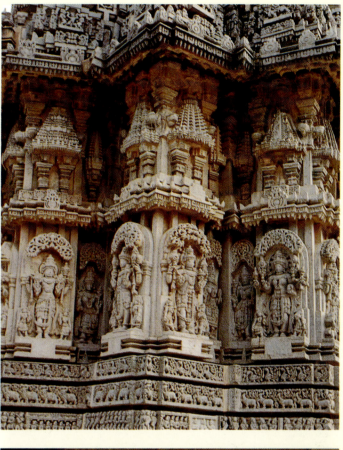

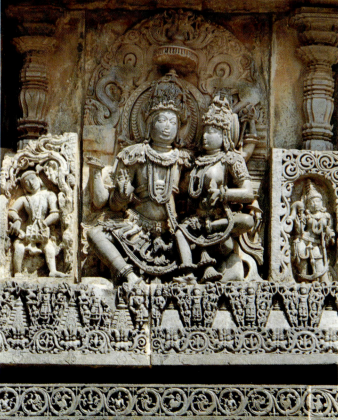

Top and above: Details of fine carvings at Belur and Somnathpur.

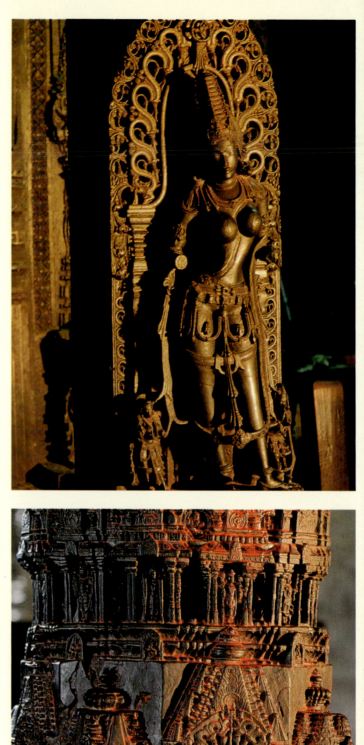

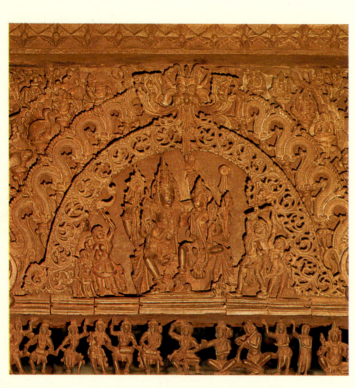

Some of the sculptures on the Chennakesava
temple at Belur are so finely worked, they resemble filigree.

Facing page: In the temple courtyard is a
monolithic stone column which is said to be held in position solely
by the force of gravity.

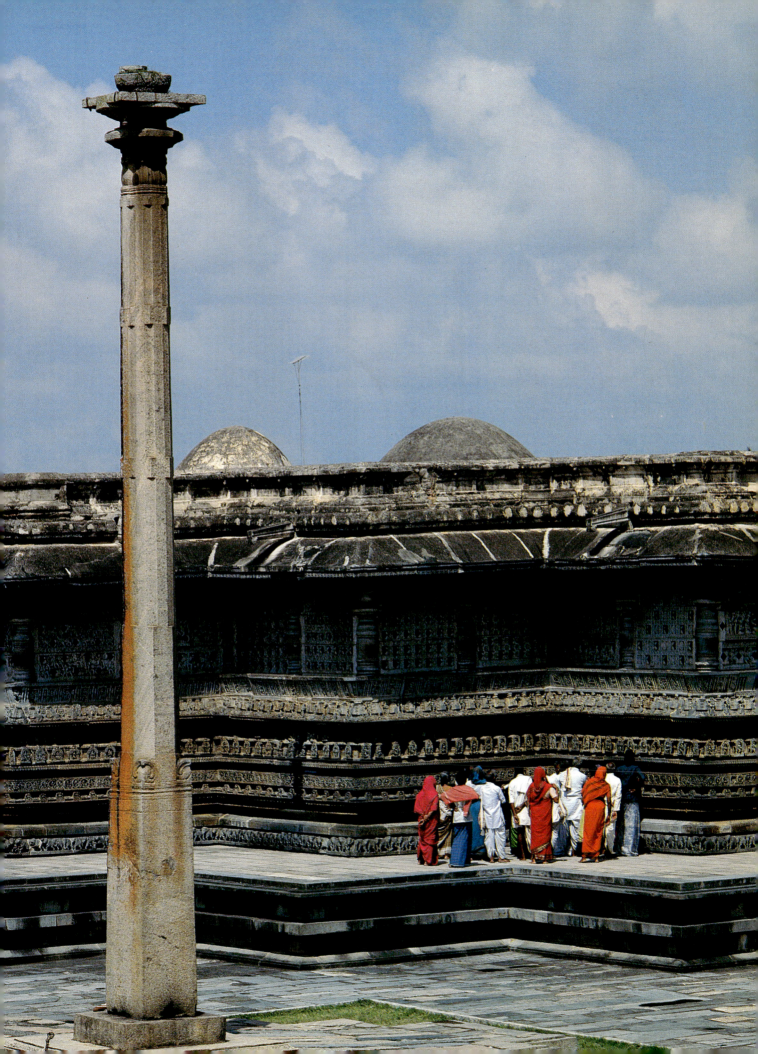

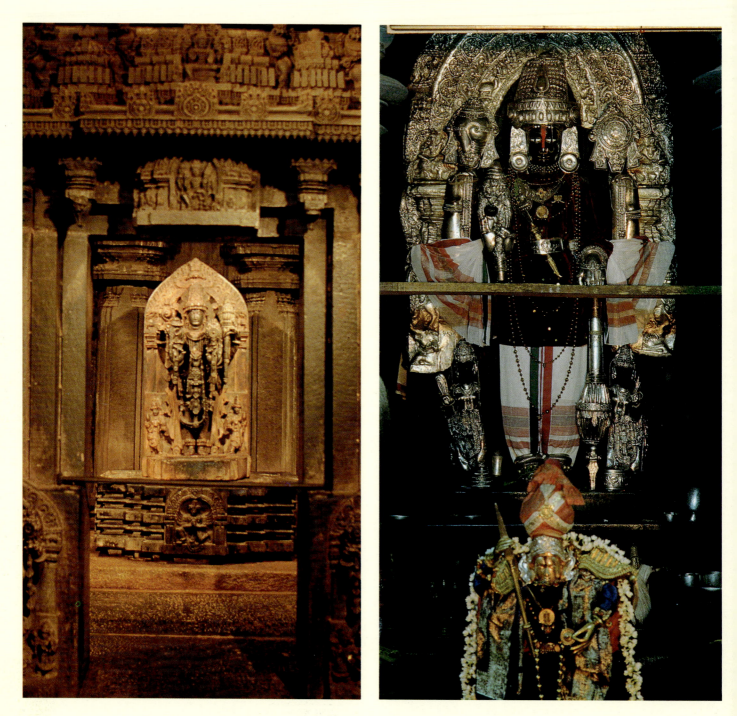

The sanctum of the Kesava temple in Somnathpur is intricately carved.

The sanctum of the Chennakesava temple at Belur.

Facing page: A sculptured pillar in the 16th century temple at Hampi.

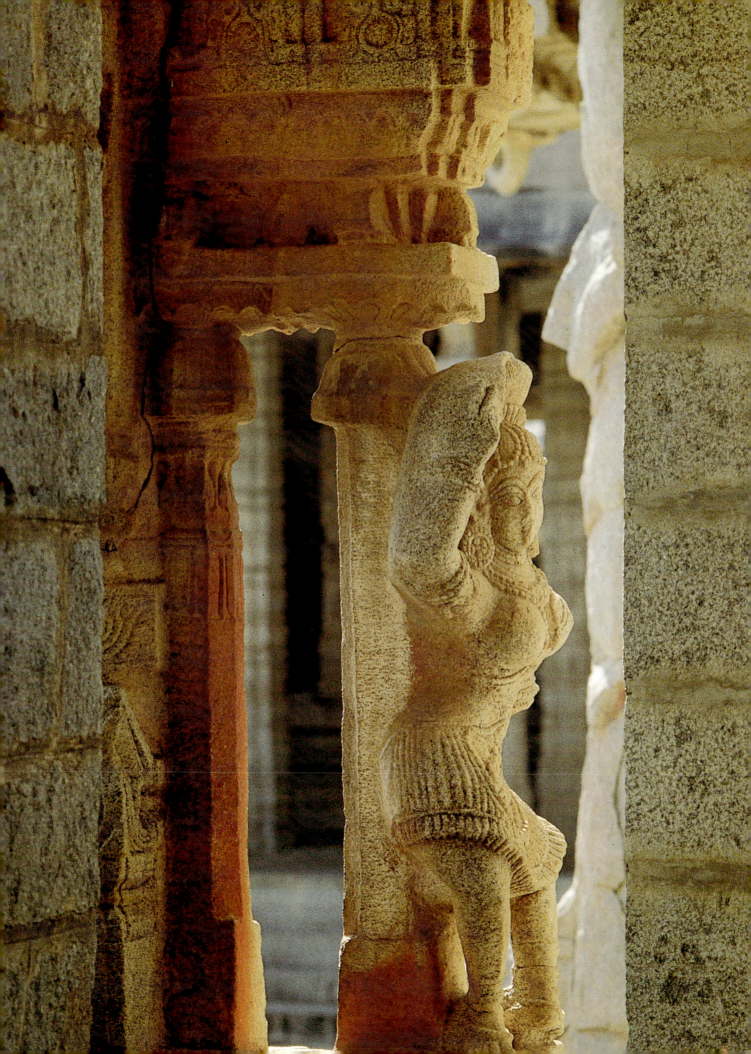

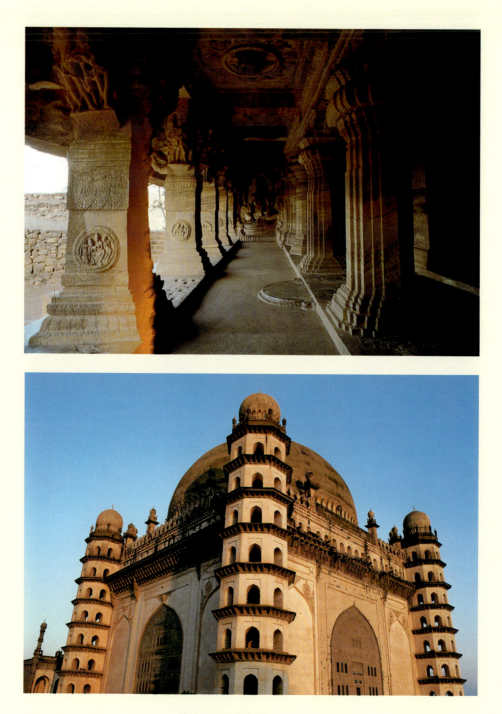

Above: The Gol Gumbaz in Bijapur
is believed to have the second largest dome in the world.

Top: The rock-cut cave temple at Badami is dedicated to Lord Vishnu.

A detail of the calligraphic decoration on the walls of the mosque in Bijapur.

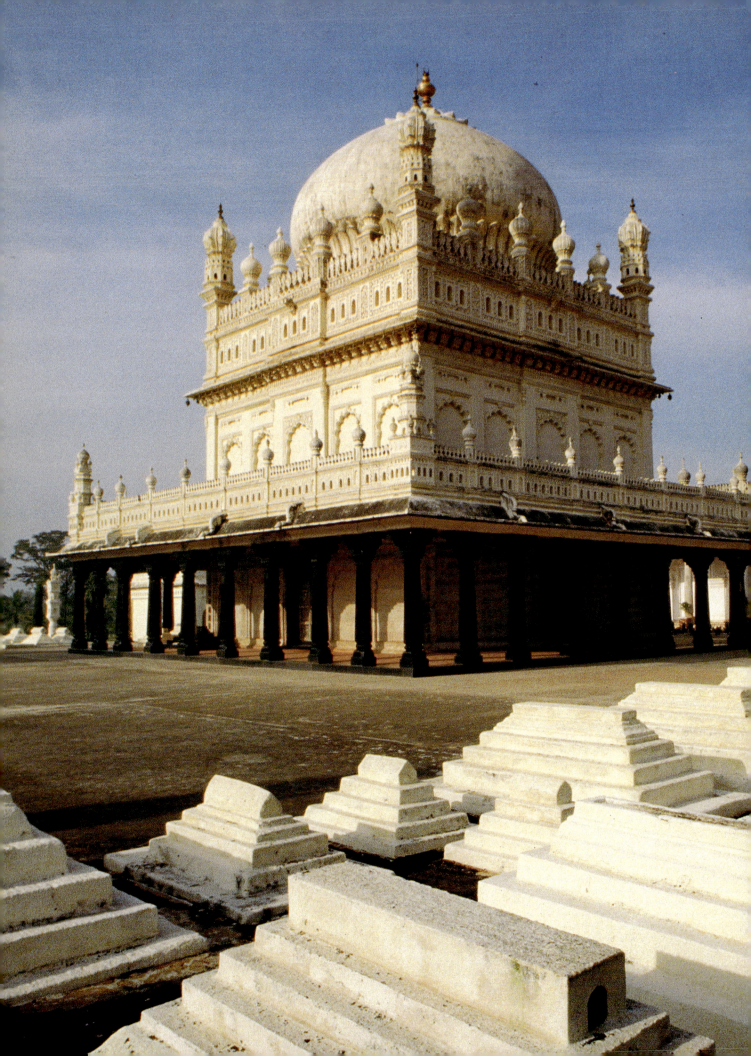

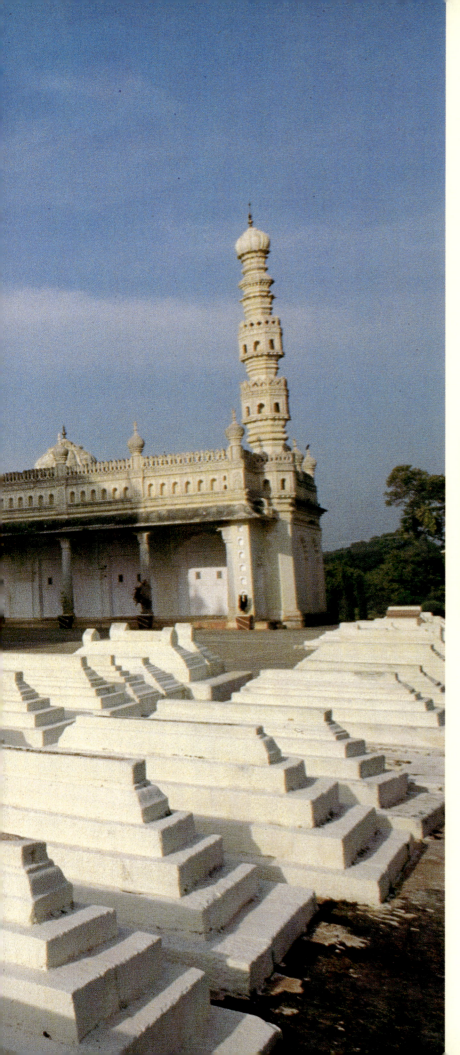

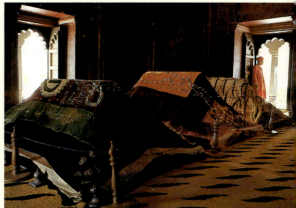

Left: Tipu Sultan's tomb at Srirangapatnam.

Above: The interior of Tipu Sultan's tomb.

Following page: A mural on the wall of Tipu Sultan's summer palace at Srirangapatnam depicts a victorious battle.

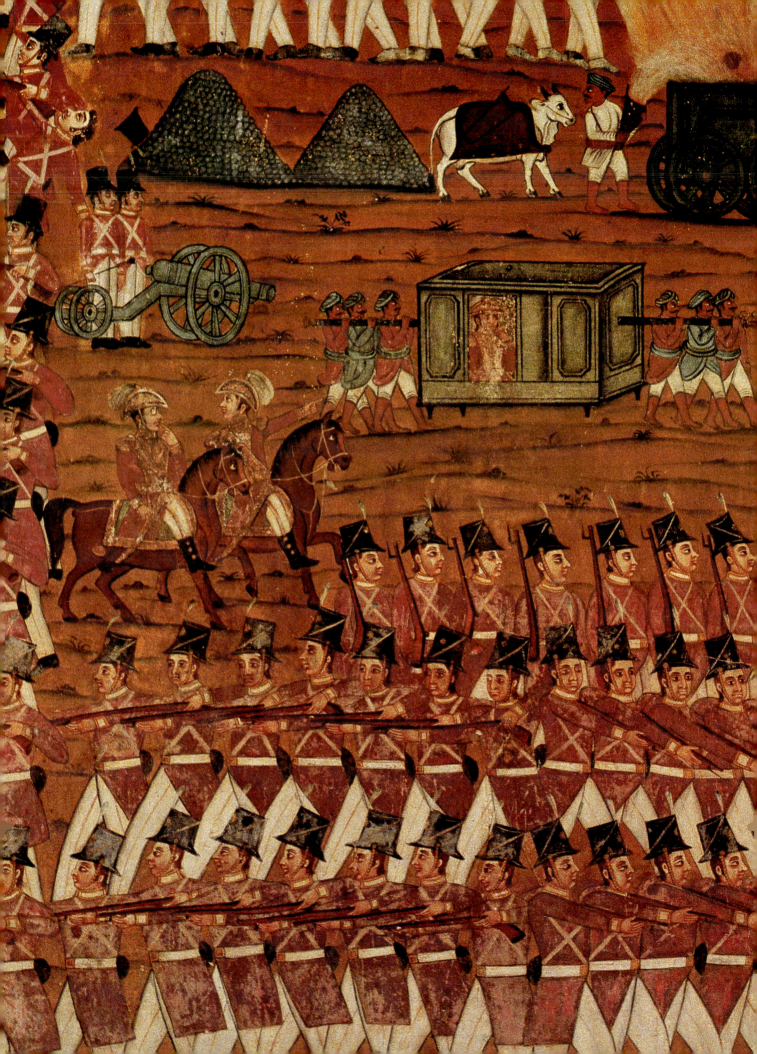

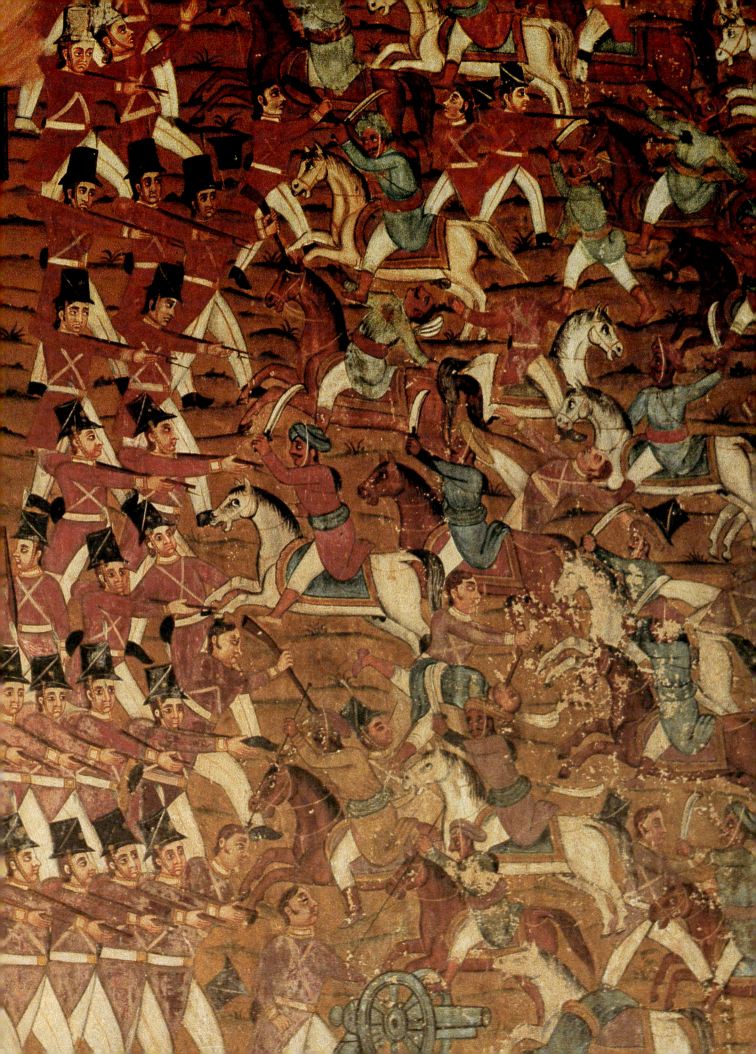

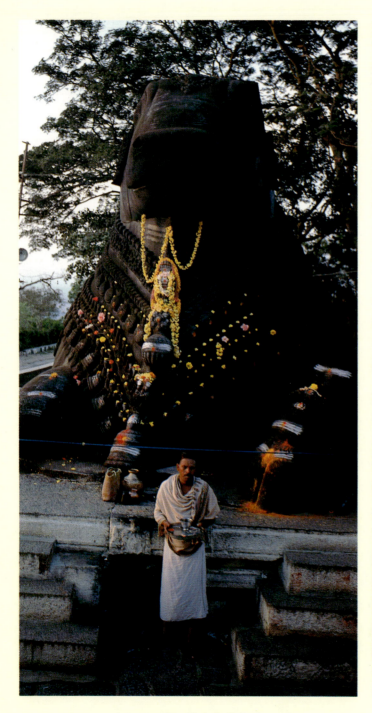

*A massive statue of Nandi, the bull, dominates the
top of Chamundi Hill in Mysore.*

*An image of Hanuman, the monkey-god,
in a temple in Bangalore.*

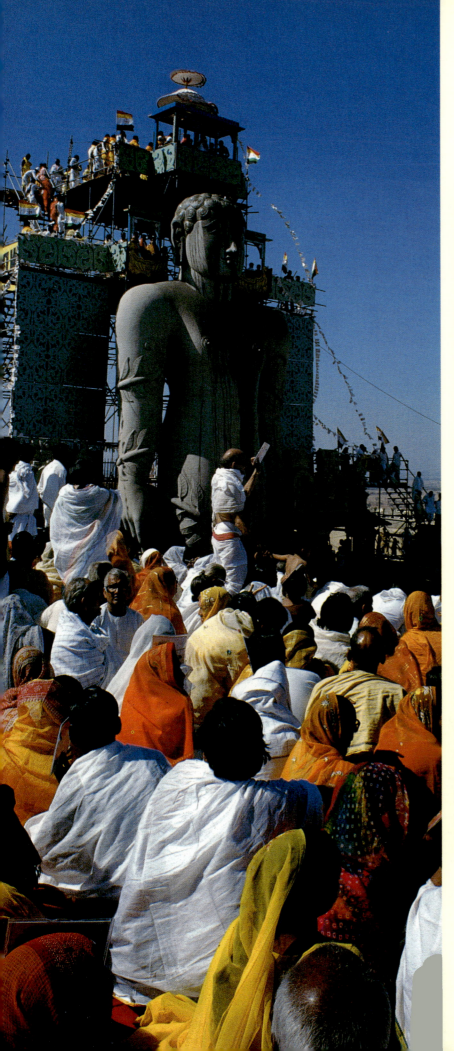

*Left: The enormous monolithic
stone statue of Jain saint Bahubali
Gommateshwara at Shravanabelgola is ritually
bathed once every twelve years.*

*Top: Priests making offerings at the feet of the
statue of Bahubali Gommateshwara.*

*Above: Images of Adinatha, a Jain Tirthankara
at Shravanabelgola.*

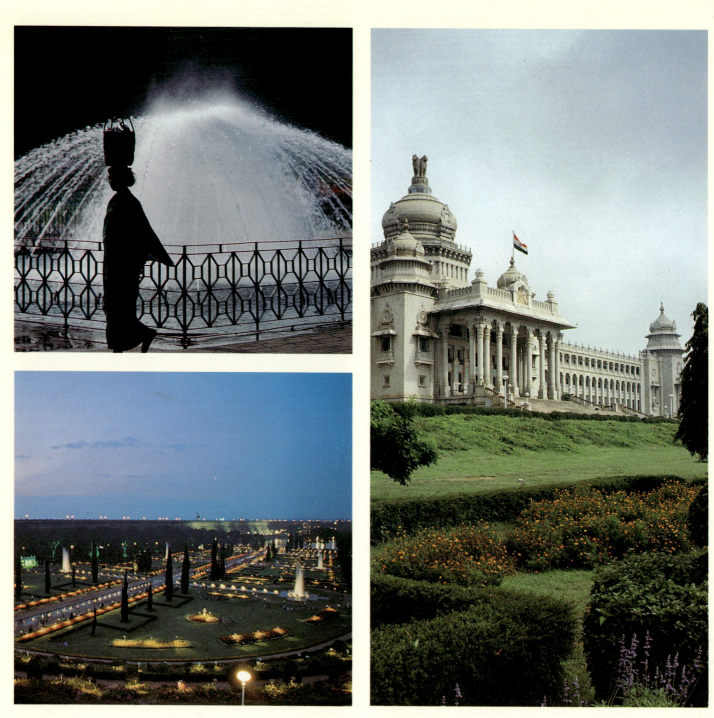

Brindavan Gardens near Mysore.

Vidhana Soudha, the Legislative Assembly of Karnataka

Facing page: Jog Falls, the largest waterfall in India.

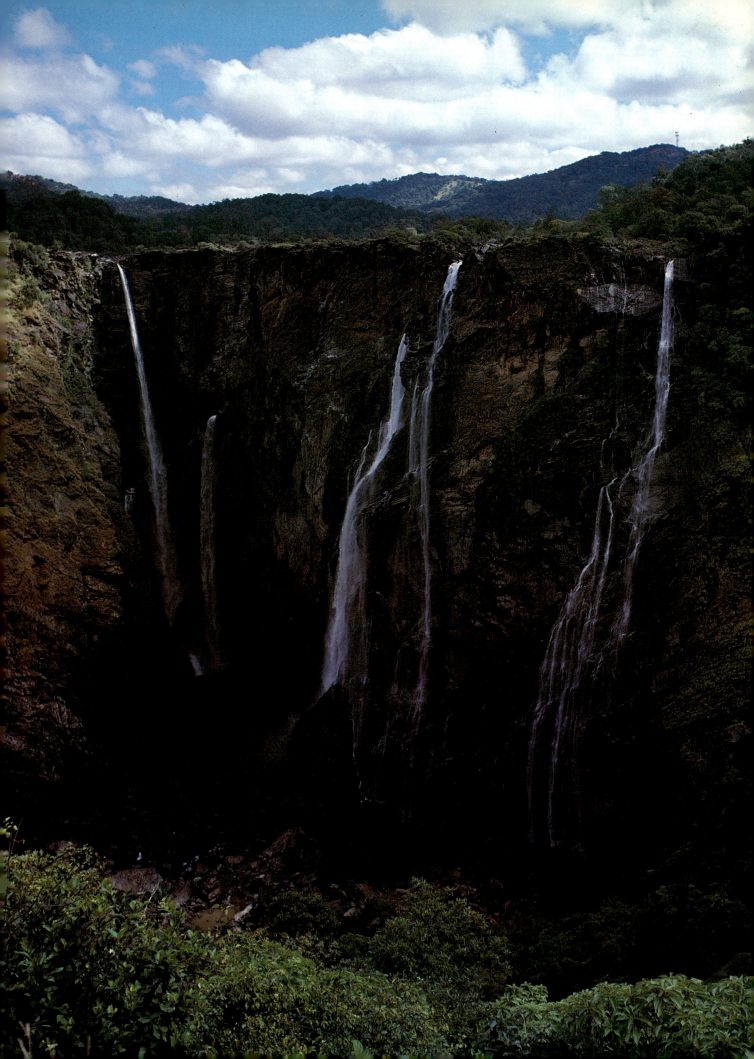

ANDHRA PRADESH

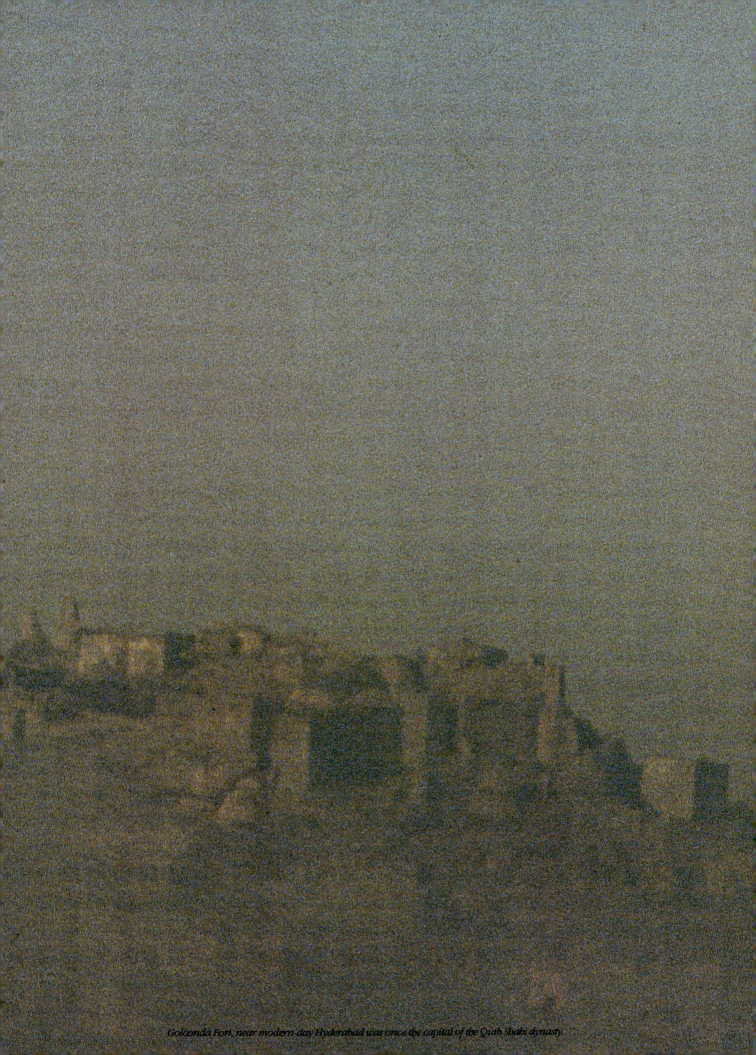

Golconda Fort, near modern-day Hyderabad was once the capital of the Qutb Shahi dynasty.

Above: The tombs of the Qutb Shahi rulers lie outside Golconda Fort.

Facing page: A statue of the Buddha at Nagarjunakonda, once a flourishing centre of Buddhism.

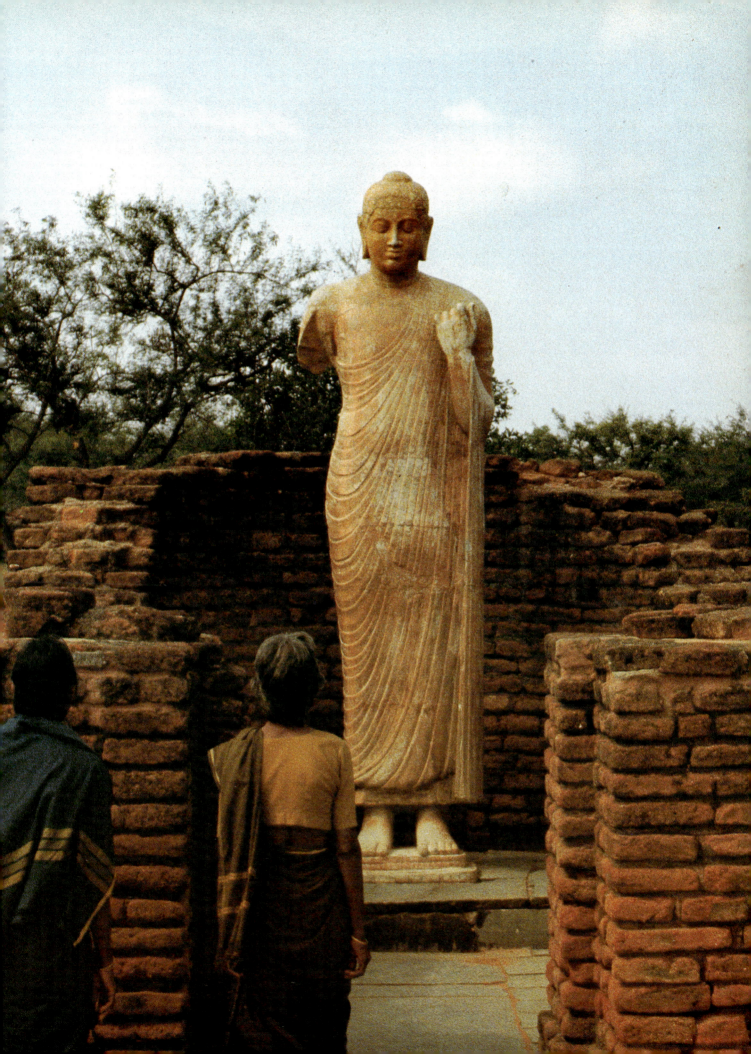

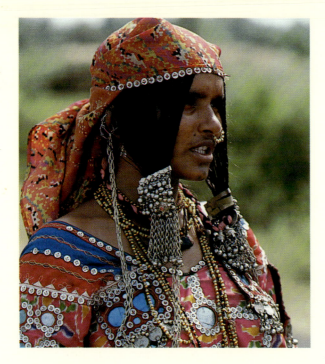

Banjara gypsy women wear vivid-hued garments.

Pilgrims to the temple at Tirupati frequently ma

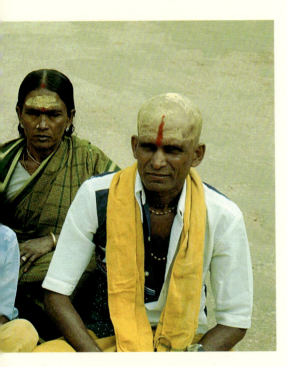

...ng of their hair in homage to Lord Venkateswara.

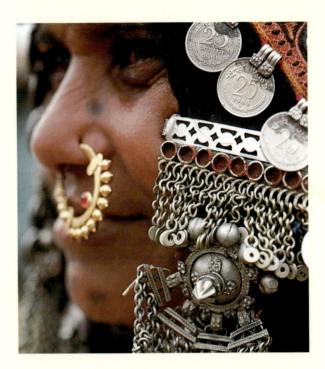

The nomadic Banjara women wear heavy silver jewellery.

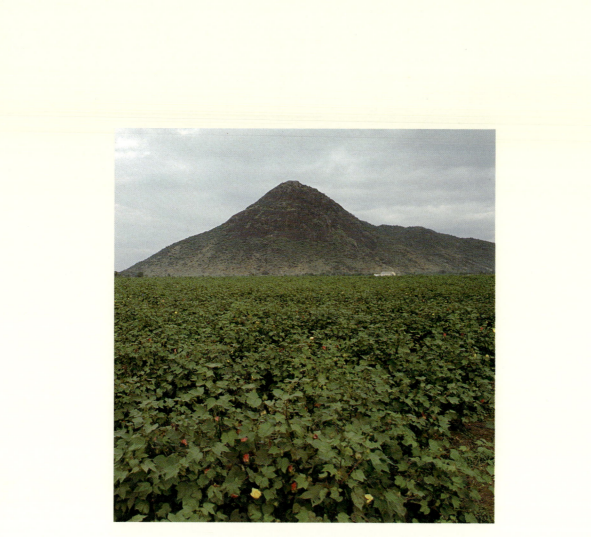

Above: Cotton grows well in the black cotton soil near Amaravathi.

Facing page: Worshippers at a temple near Vijaywada.

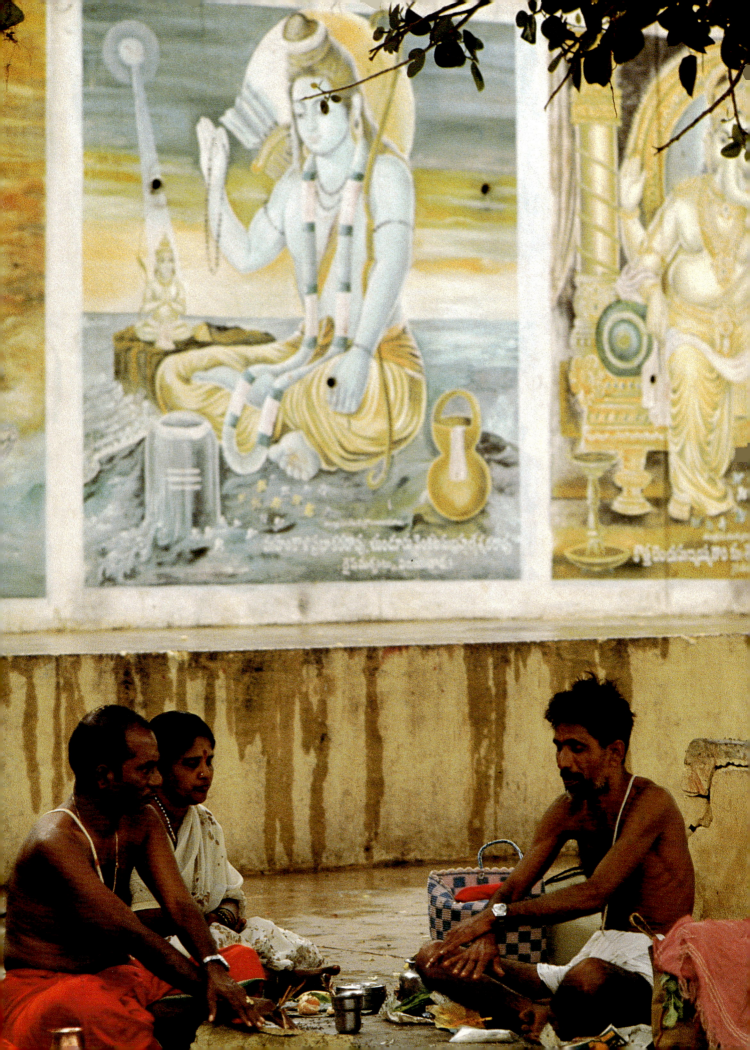

Top: Coconuts are used as offerings at temples.

Above: A Priest at the shrine to Lord Venkateswara at Tirupati.

Facing page: The temple to Lord Venkateswara at Tirupati is one of the richest in the world.

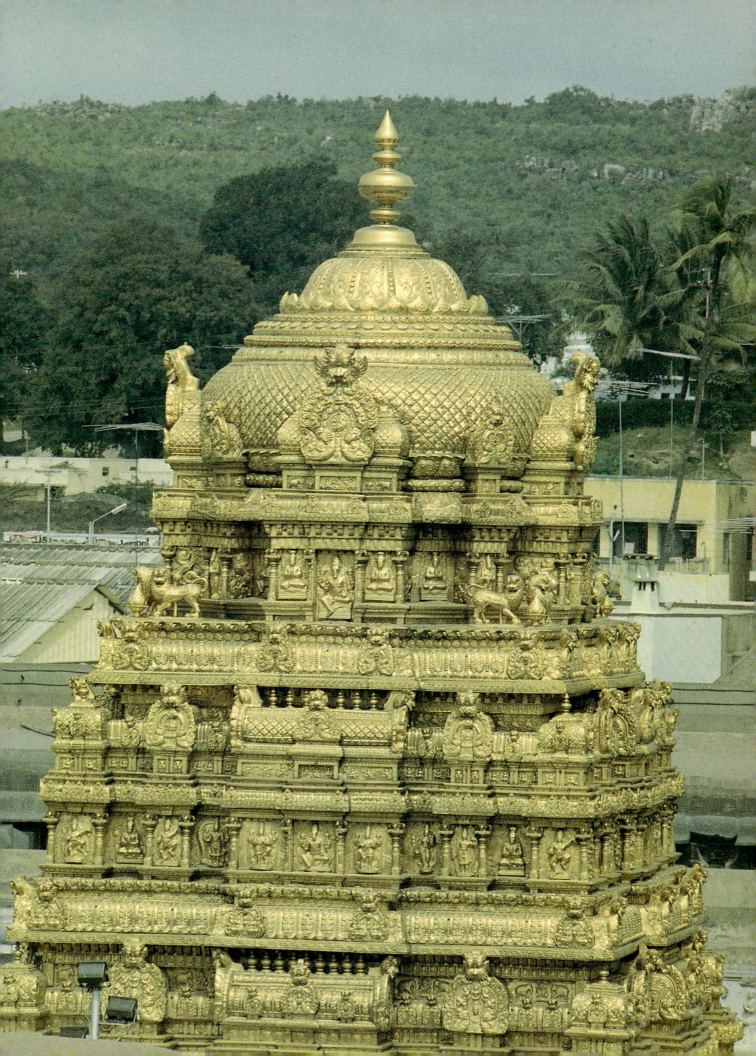

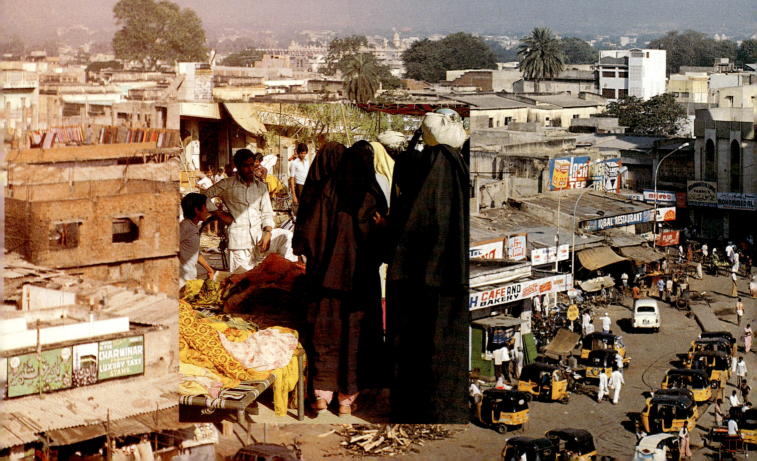

The Charminar, in the heart of Hyderabad,
is the most famous monument in the city.

Inset: Bazaars filled with glittering
baubles crowd the busy streets around the Charminar.

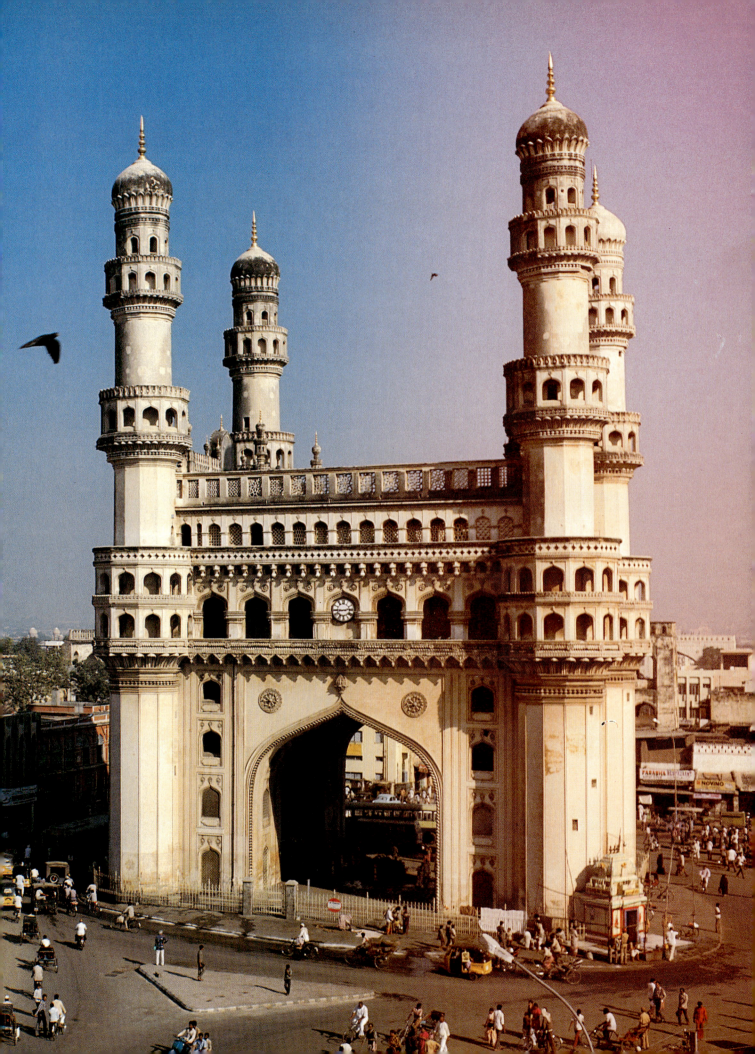

The River Krishna at Vijayawada.

Vijayawada is one of Andhra Pradesh's largest towns.

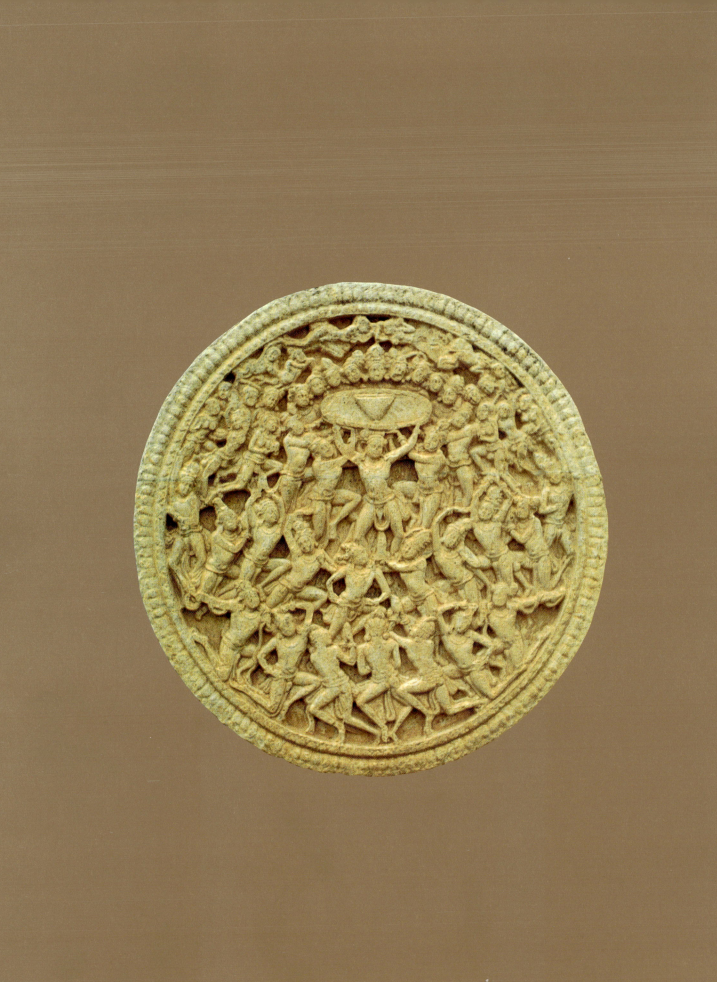

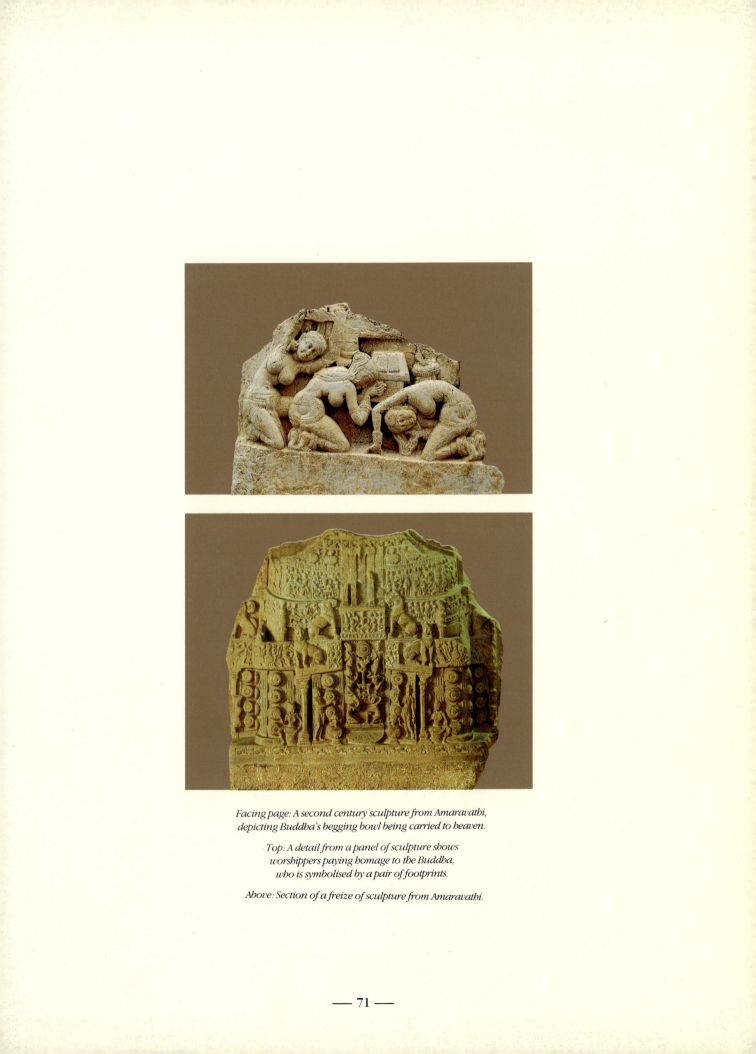

*Facing page: A second century sculpture from Amaravathi,
depicting Buddha's begging bowl being carried to heaven.*

*Top: A detail from a panel of sculpture shows
worshippers paying homage to the Buddha,
who is symbolised by a pair of footprints.*

Above: Section of a freize of sculpture from Amaravathi.

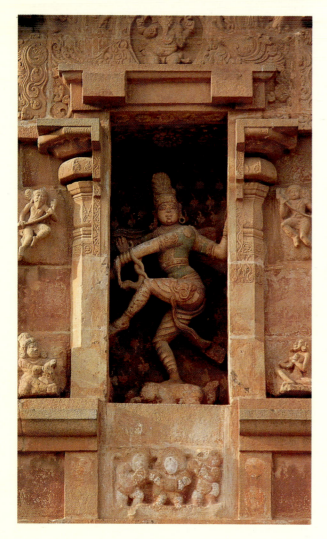

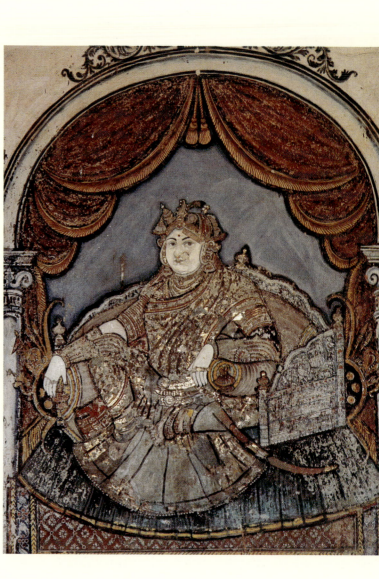

Above: An image of the dancing Shiva at Thanjavur.

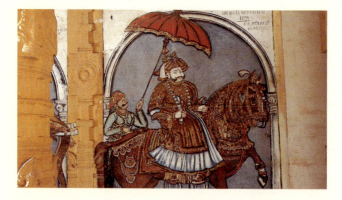

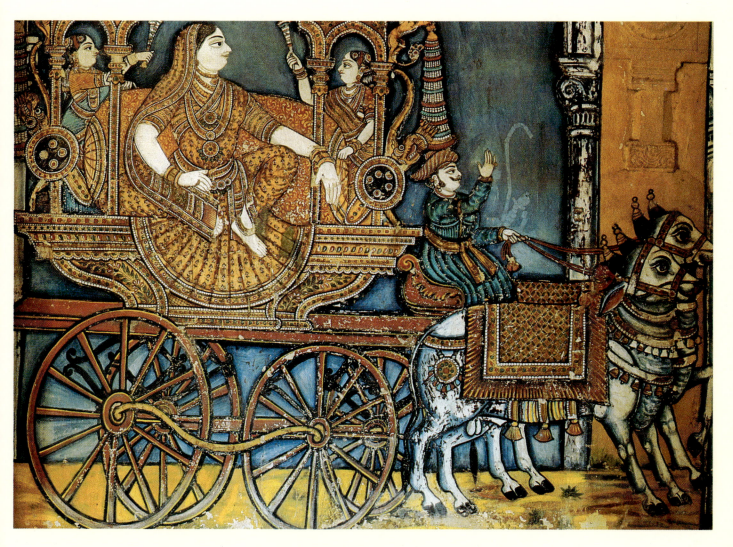

Left above & below: Paintings in the Chola style in the temple complex portray the patrons of the temple.

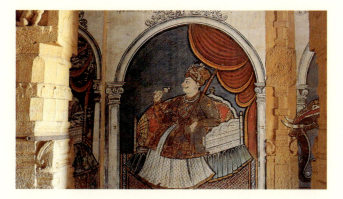

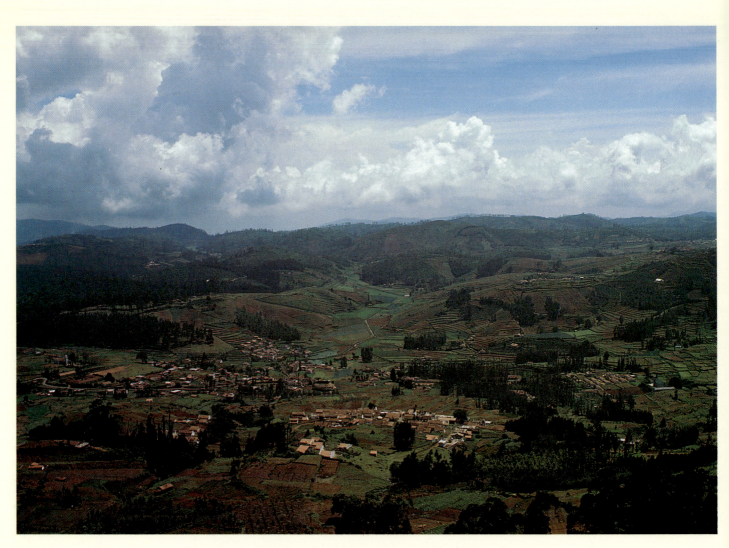

Above: Ooty or Udagamandalam as it is now called,
is a hill station in the Nilgiri Hills.

Below: Boating on the Ooty Lake is a popular pastime.

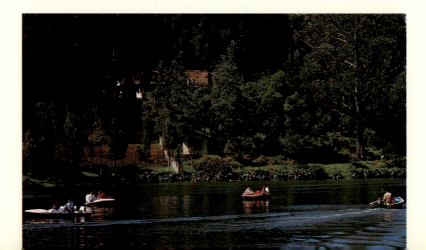

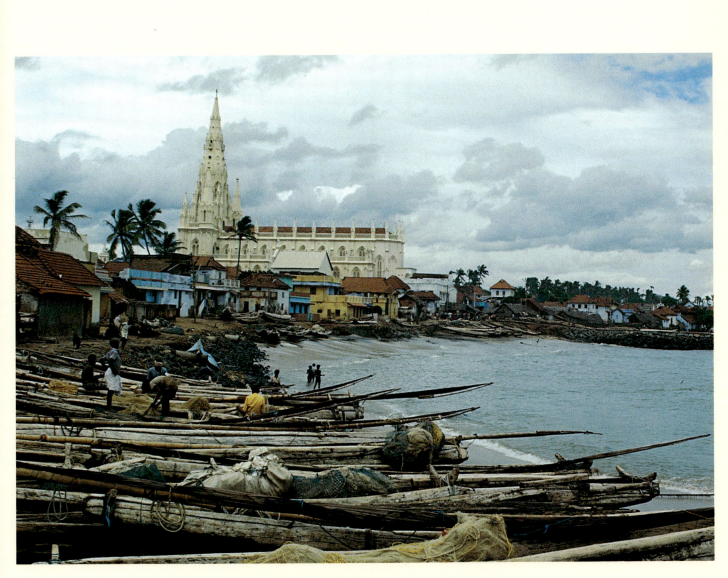

Above: A church in a small fishing village on the Tamil Nadu Coast.

Below: A memorial to Swami Vivekanand on a rock at Kanniyakumari.

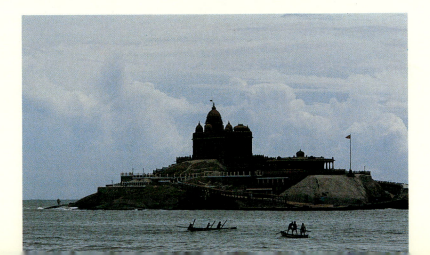

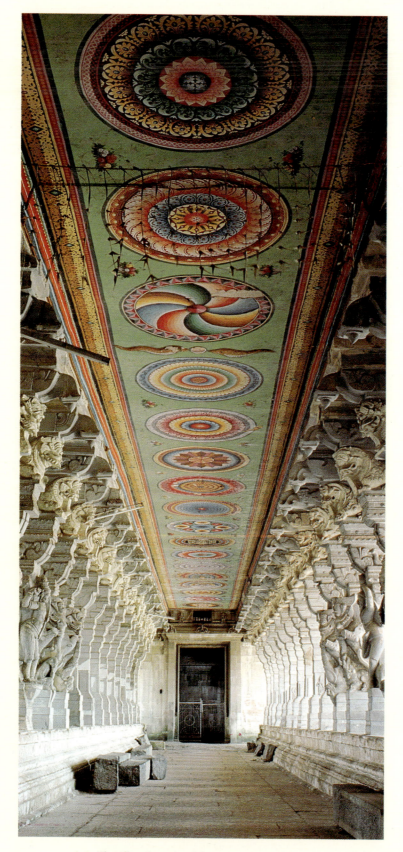

The pillared arcades of the Rameswaram temple
are a kilometre in length.

Facing page: Bharatanatyam dancer Leela Samson practises a
traditional art form which is centuries old.

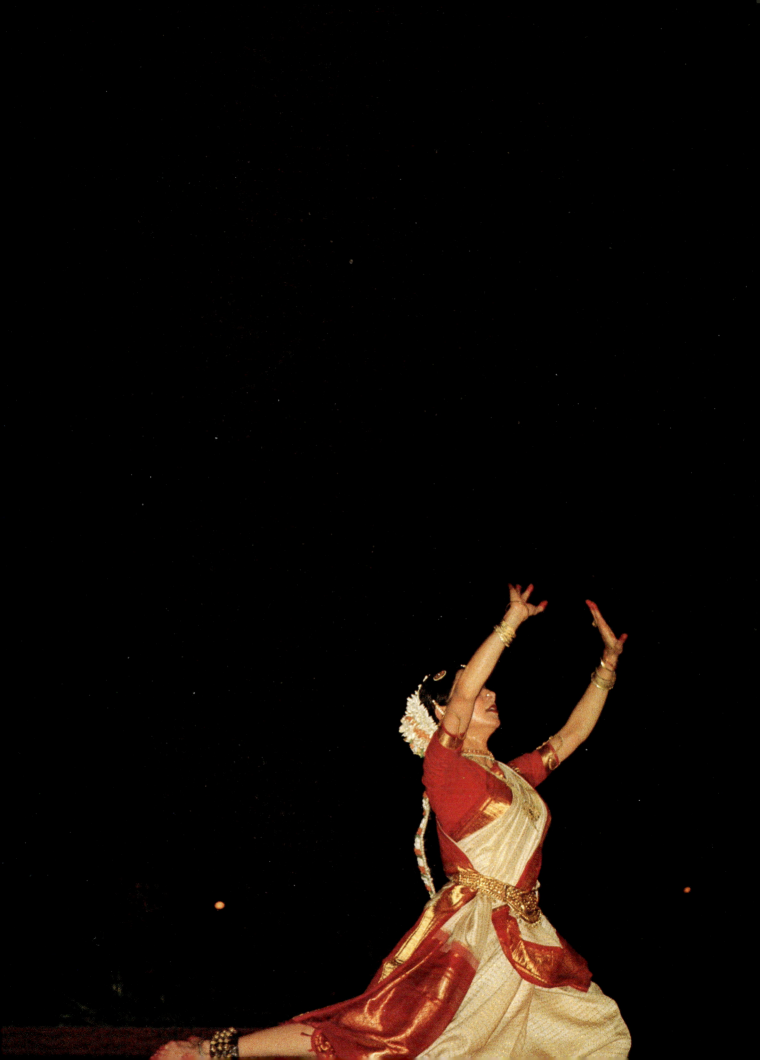

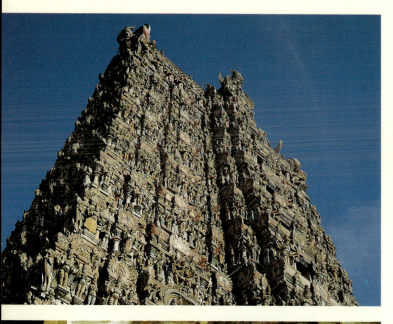

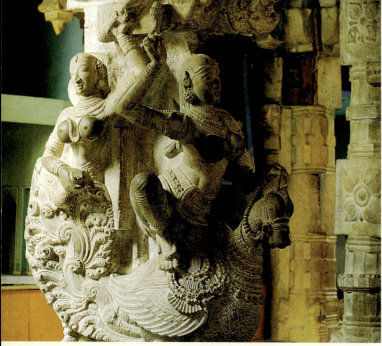

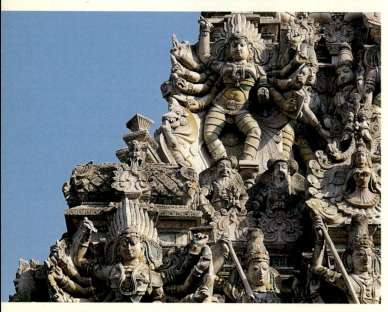

The Thousand-Pillared Hall in the Meenakshi
Temple at Madurai.

Top: The main gate to the Meenakshi Temple is
intricately carved.

Centre: Each of the thousand pillars in the hall of
that name, is carved with different images.

Below: Details of sculpture from the main gate of
the Meenakshi temple.

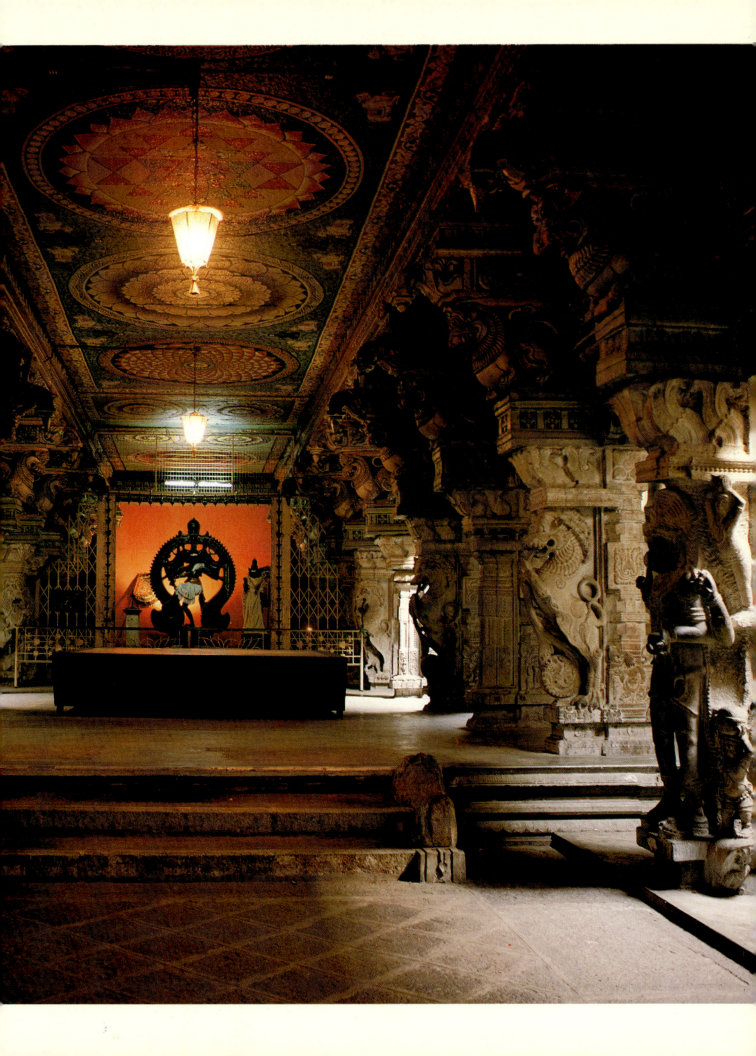

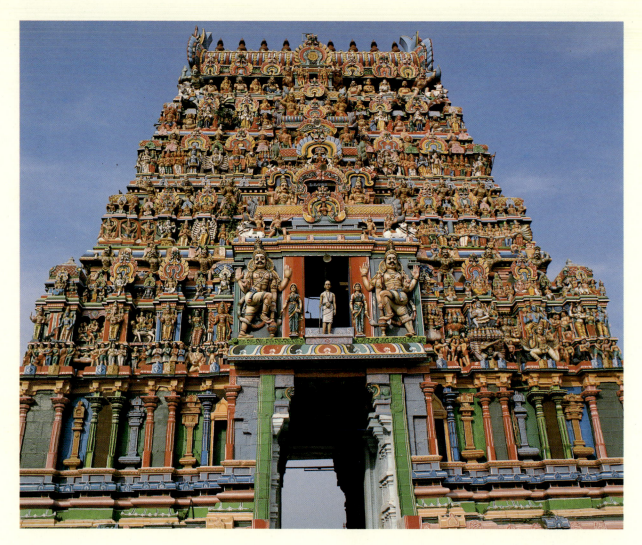

Intricate sculptures on the Nageshwaraswamy Temple at Kumbakonam.

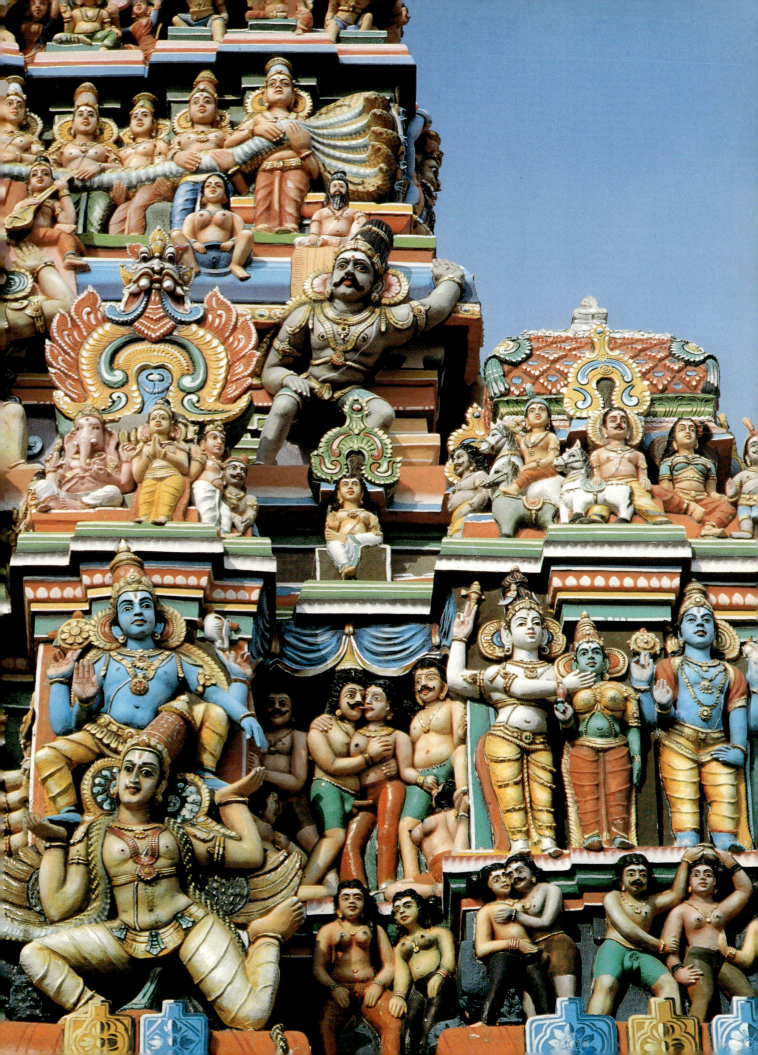

A wooden carving from the palace at
Padmanabhapuram.

A ritual brass lamp depicting a warrior in the
Padmanabhapuram Palace.

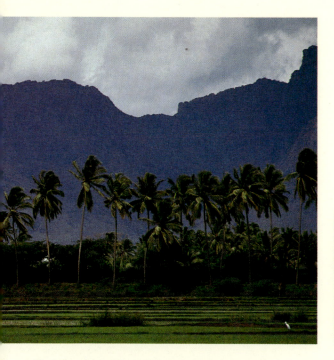

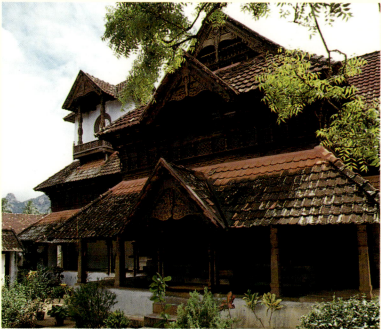

The Palace is located in a hilly area and surrounded by paddy fields and coconut palms.

The Padmanabhapuram Palace has a characteristically Kerala style double roof.

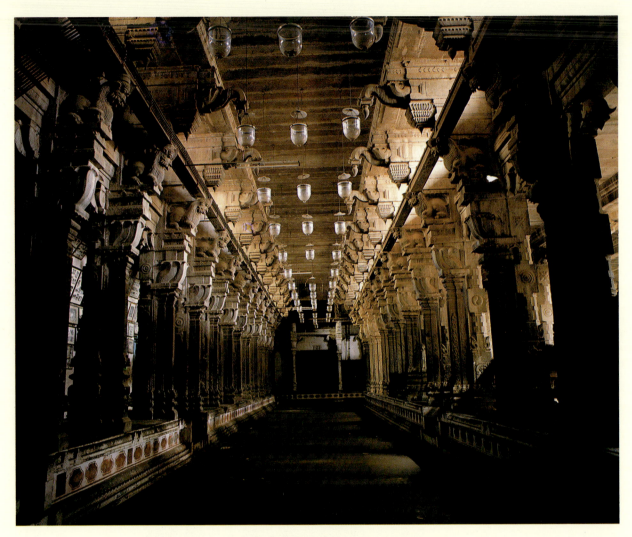

The fourteenth century Chidambaram Temple.

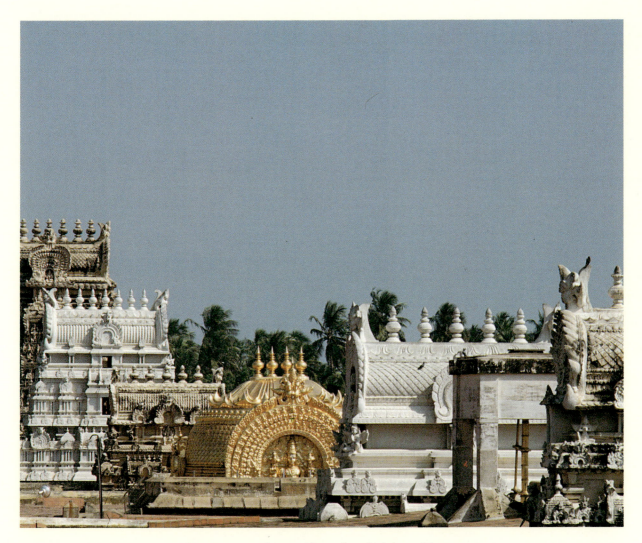

Gopurams, or temple towers cluster above the shrines at Srirangam.

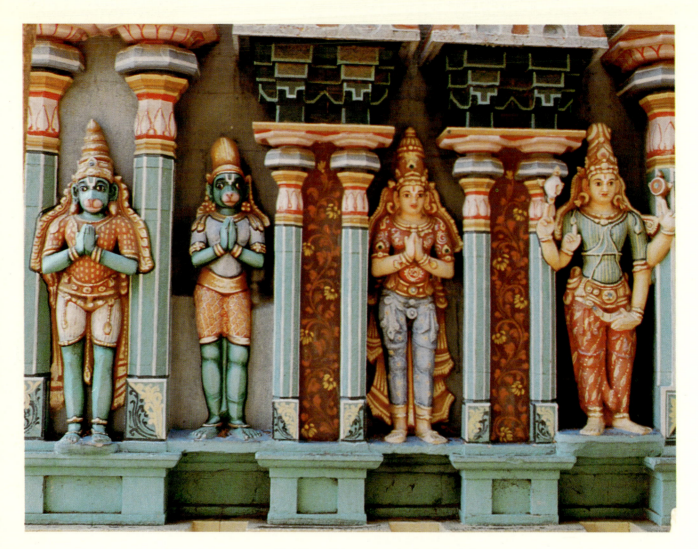

The pillars at Srirangam are intricately carved.

Below: A painting of Lord Vishnu is among many wall paintings
in the temple at Srirangam.

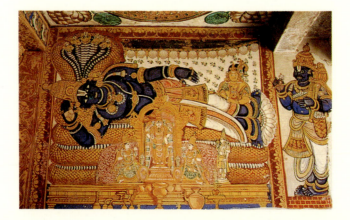

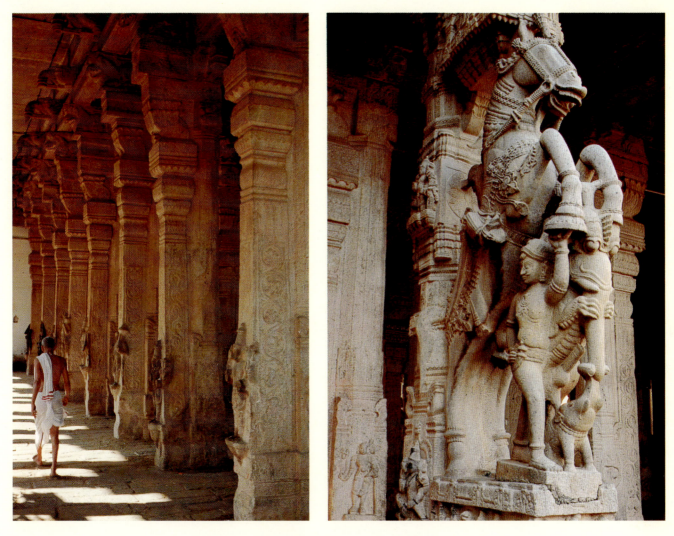

Carved pillars of the thousand-pillared temple at Srirangam.

Below: A lyrically beautiful scultpure of a veena player..

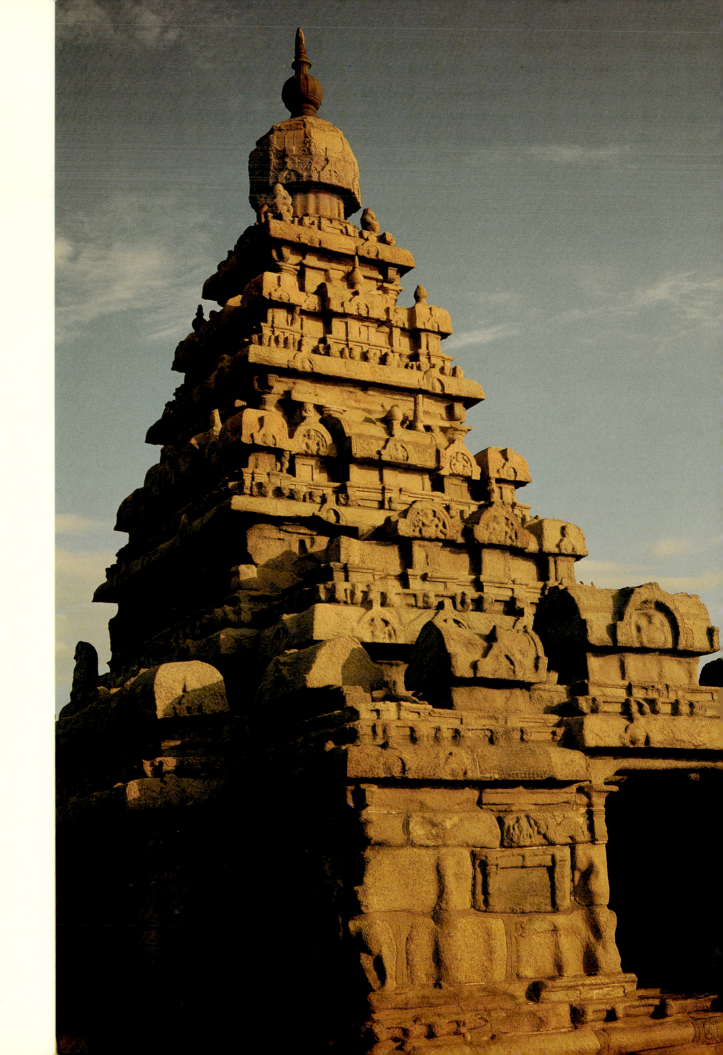

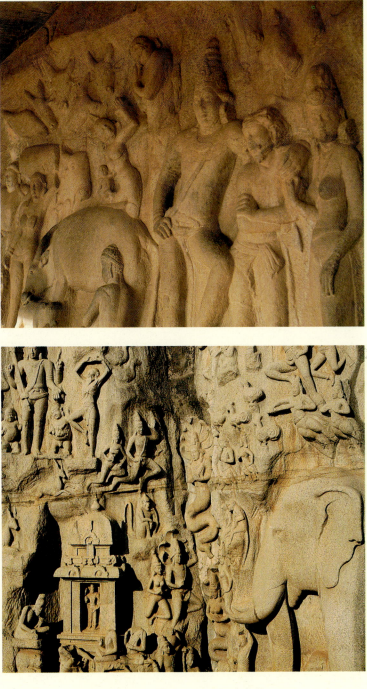

Left: The impressive shore temple at Mahabalipuram.

*Top: A detail of one of the relief sculptures
inside a cave temple at Mahabalipuram.*

*Above: A bas-relief called Arjuna's Penance or the Descent of the Ganga has
used a natural cleft in the rock to portray a mythological tale.*

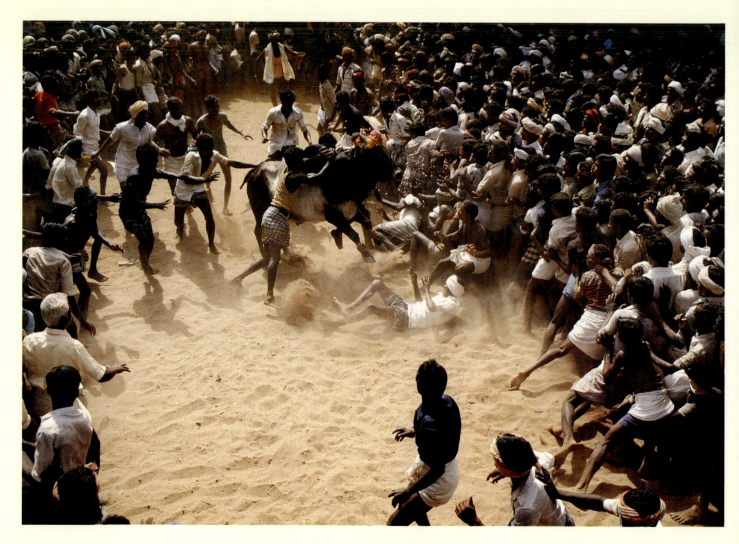

In the villages of Tamil Nadu, the festival of Pongal is a time when young men pit their strength against racing bulls.

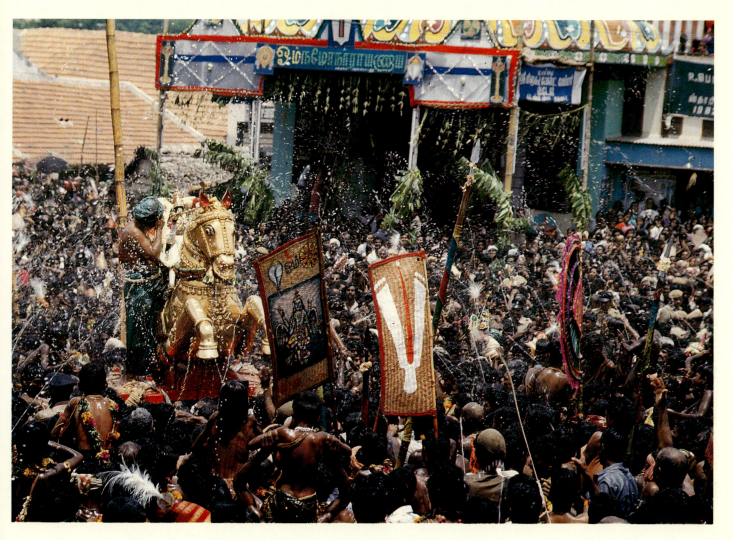

*The annual Chithrai festival in Madurai celebrates the marriage of
Lord Shiva and his consort Meenakshi.*

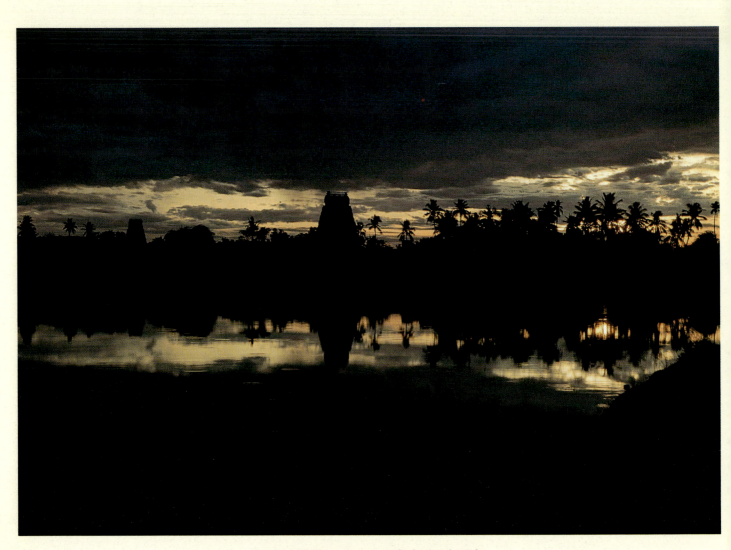

Sunset at Kancheepuram, town of a thousand temples.

Facing page: Pondicherry near Madras,
was once the capital of the French colony in India.

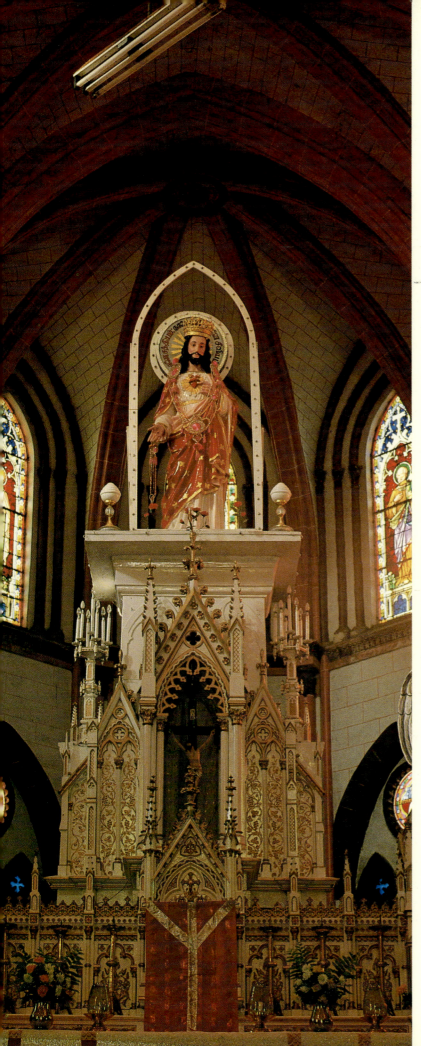

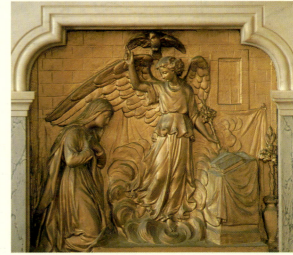

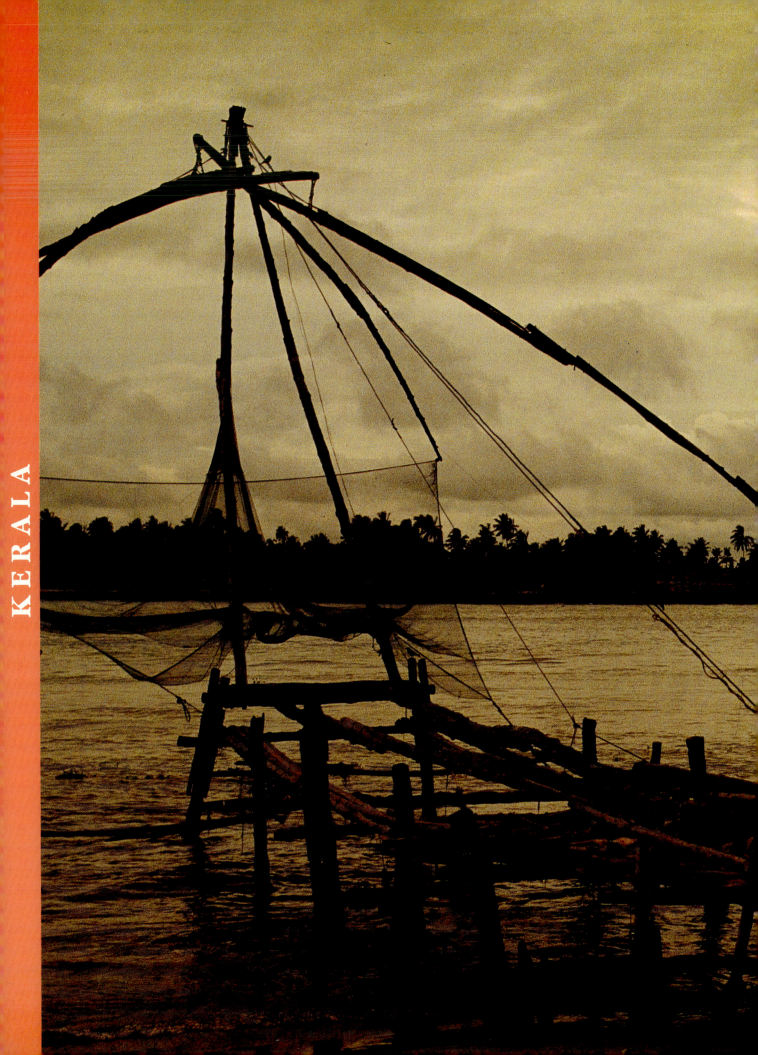

KERALA

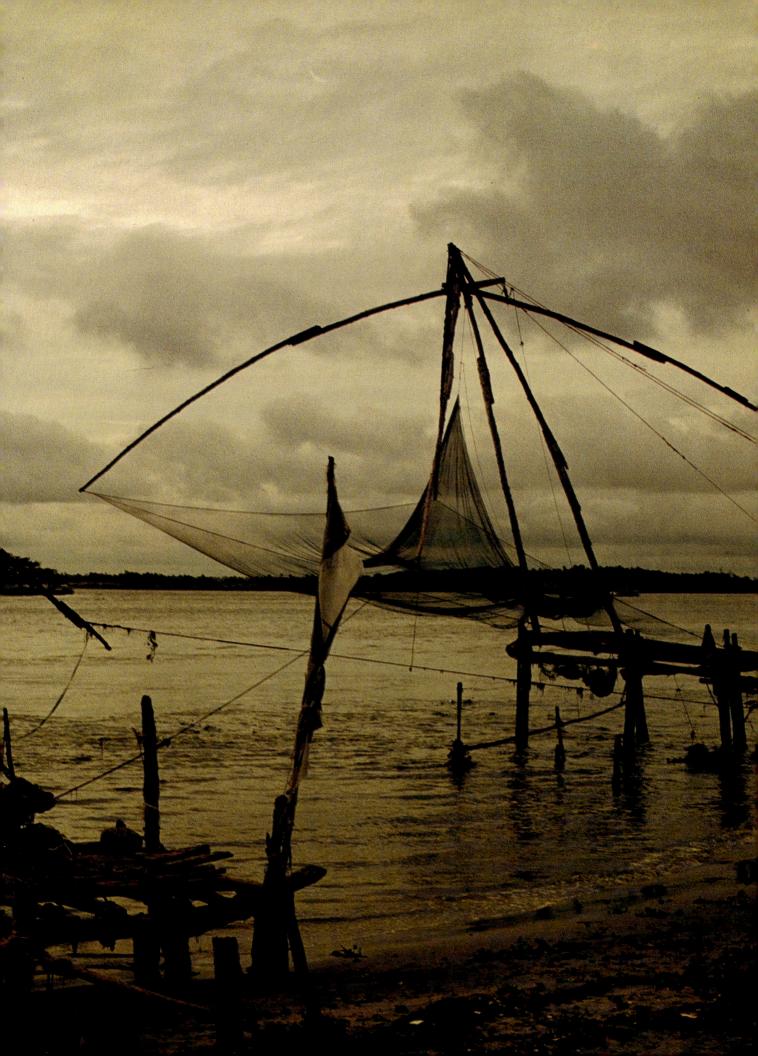

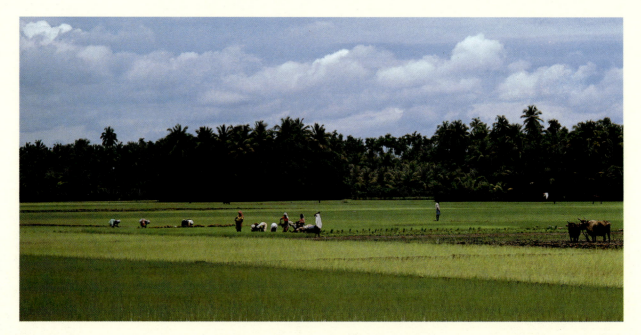

*Preceding page: The enormous Chinese fishing nets on the coast in and around Cochin
are part of Kerala's cosmopolitan heritage.*

Above: Paddy fields along the fertile coastal plain of Kerala.

*Facing page: Snake boats, such as these,
participate in annual races during the festival of Onam.*

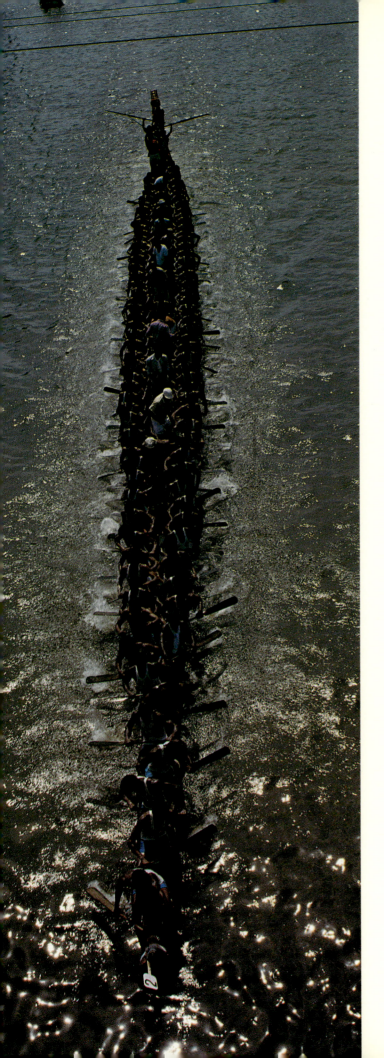

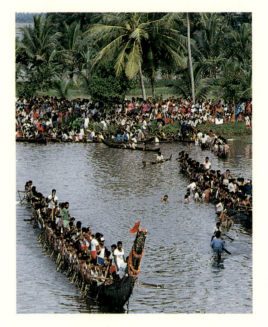

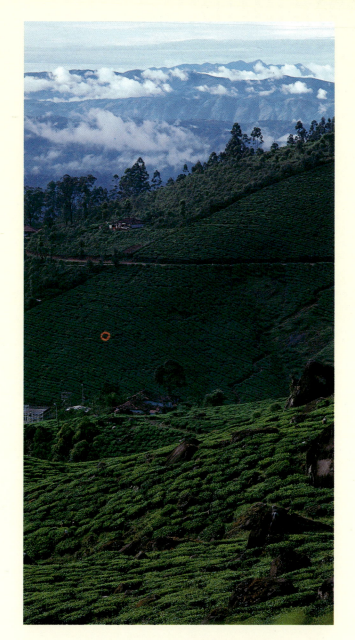

Tea bushes cover the slopes of the Western Ghats near Munnar.

Facing page: The Chiyapara waterfall near Kaladi.

Following page: A magnificent festival, the Trichur Puram is held every year, at which richly caparisoned temple elephants are taken out in procession.

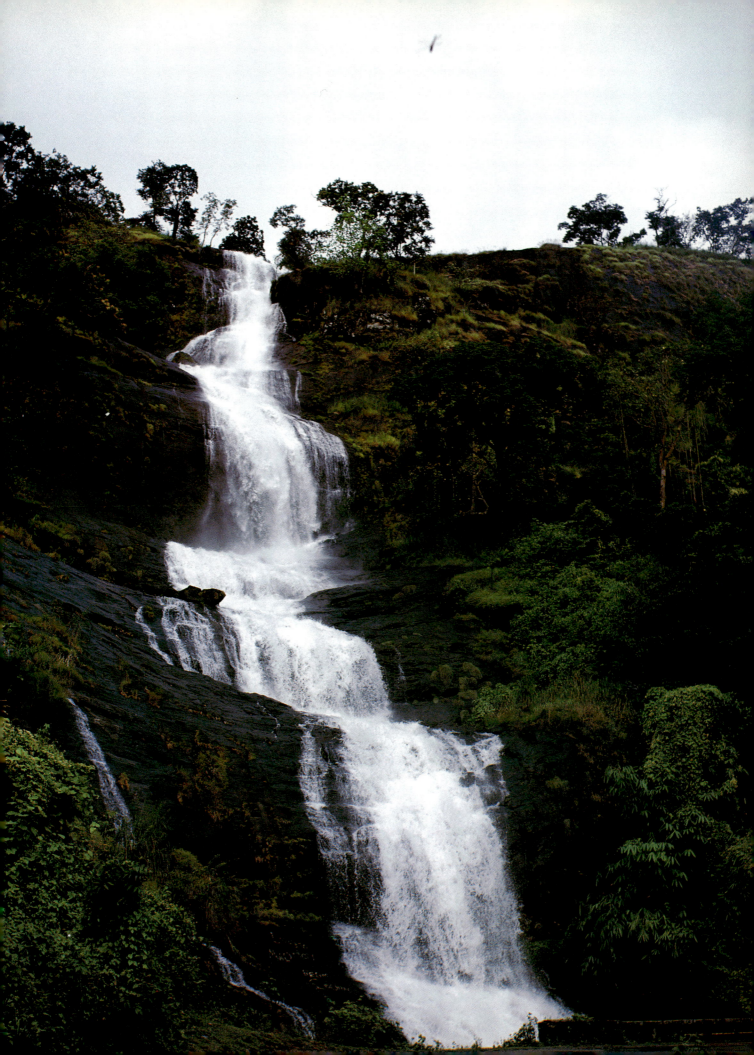

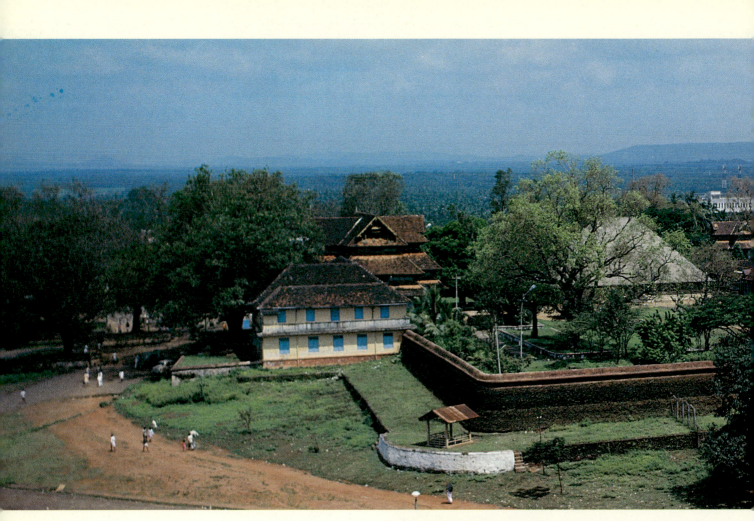

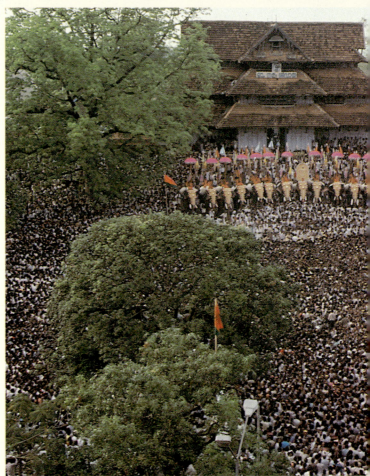

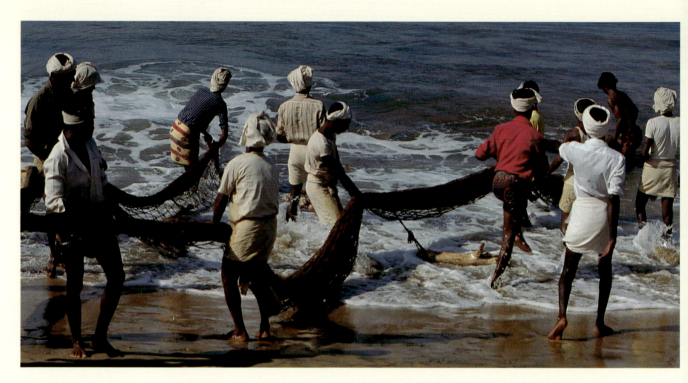

Fishermen hauling in the catch on the beach at Kovalam, near Trivandrum.

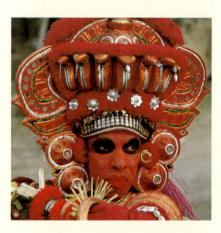

Kathakali, literally 'story-dance' is
Kerala's traditional dance style.

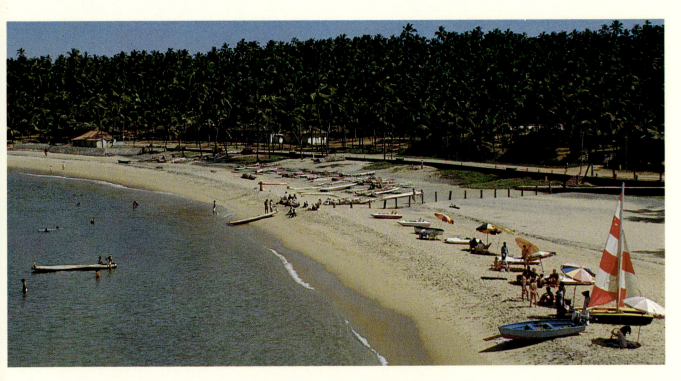

The Kovalam beach resort near Trivandrum, the capital of Kerala.

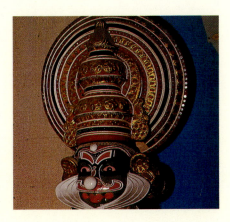

*A 'red faced' or evil character in a
Kathakali performance.*

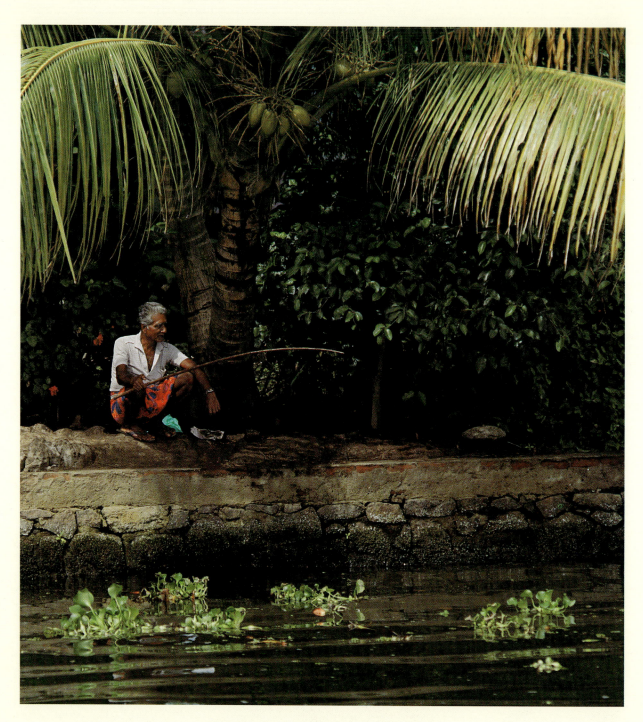

A quiet corner for a pensive fisherman near Cochin.

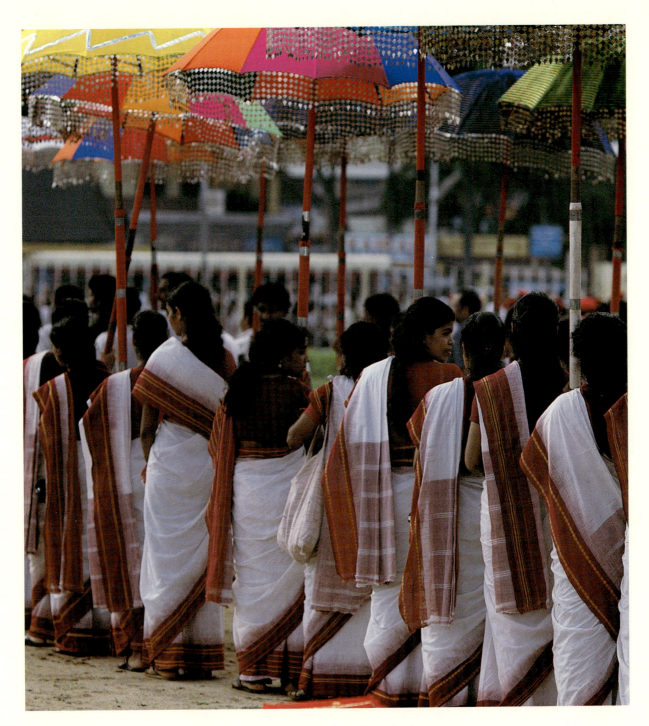

Participants in a temple festival, dressed in the Kerala style sari.

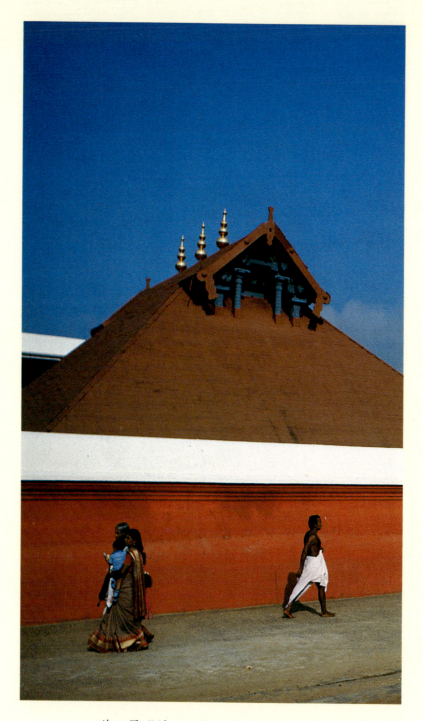

*Above: The Krishna temple at Guruwayoor is perhaps
the most famous shrine in Kerala.*

Facing page: Tea gardens at Munnar, in the Western Ghats.

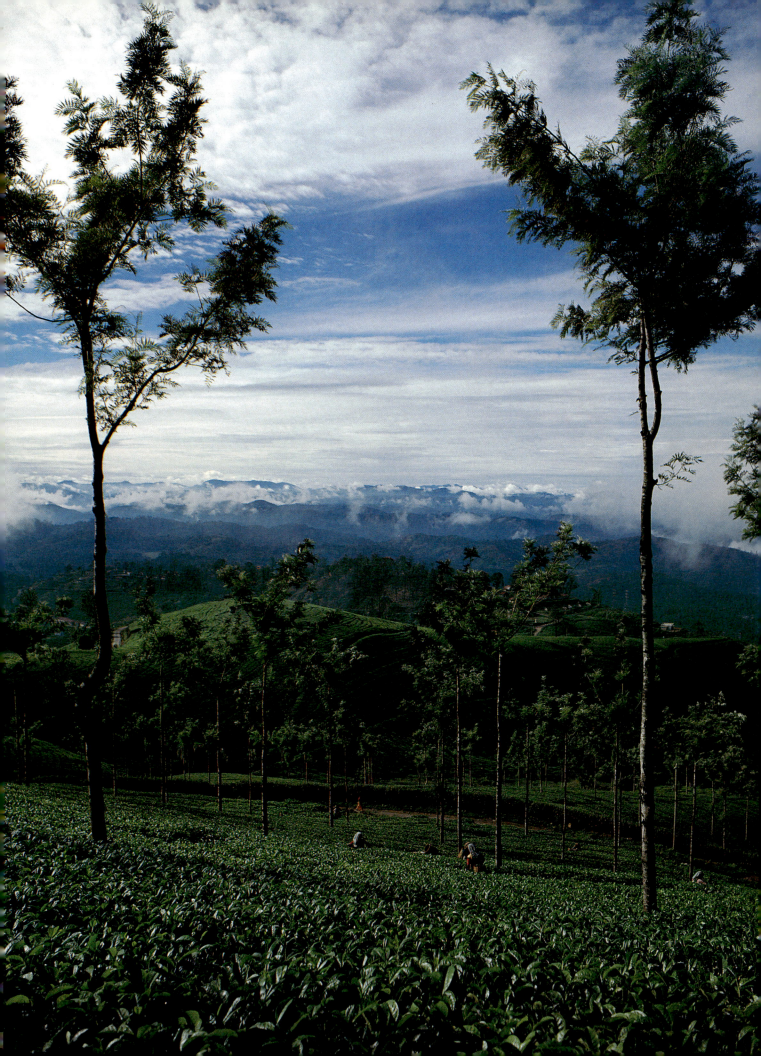

Above: The Jewish Synagogue in Cochin is one of the city's oldest places of worship.

Right: A mural in the Mattancherry Palace at Cochin.

Far right: St. Mary's Church in Cochin is one of many Christian places of worship in Kerala.

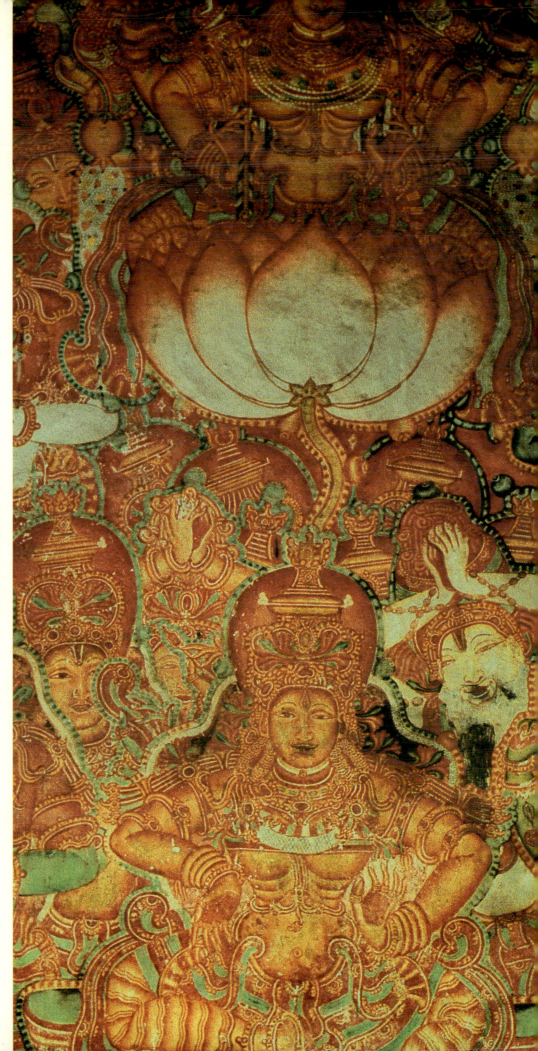

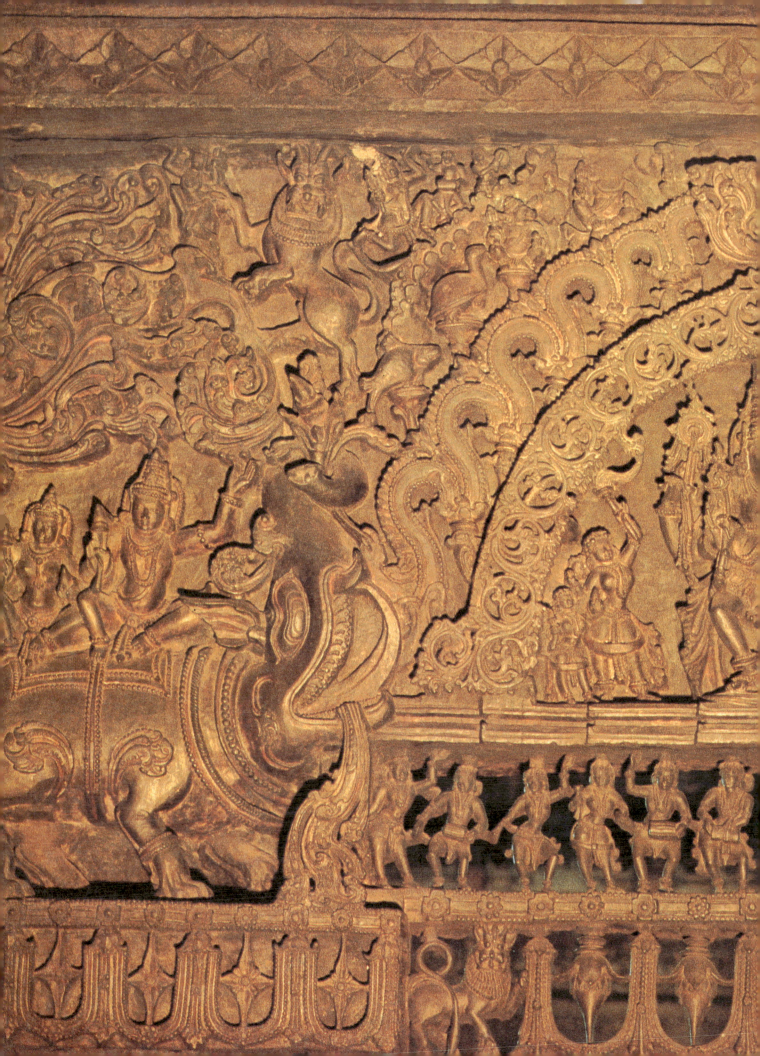